IMAGES OF St. Louis

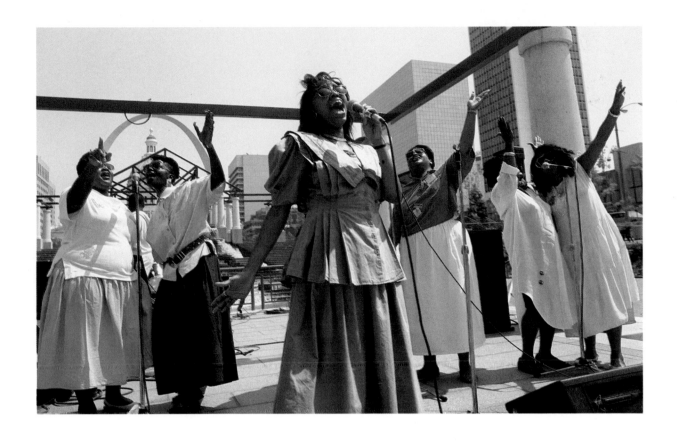

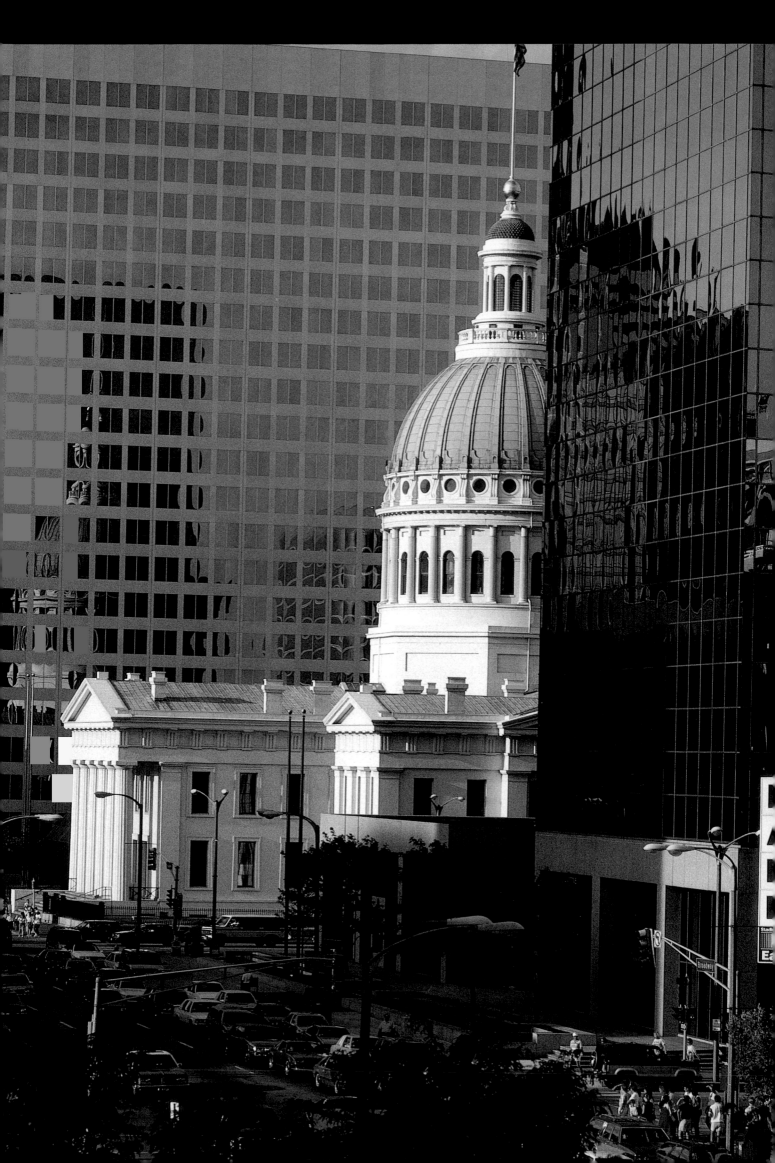

IMAGES OF
St. Louis

Contemporary Photographs Selected by QUINTA SCOTT

Introduction by ELAINE VIETS

University of Missouri Press
Columbia

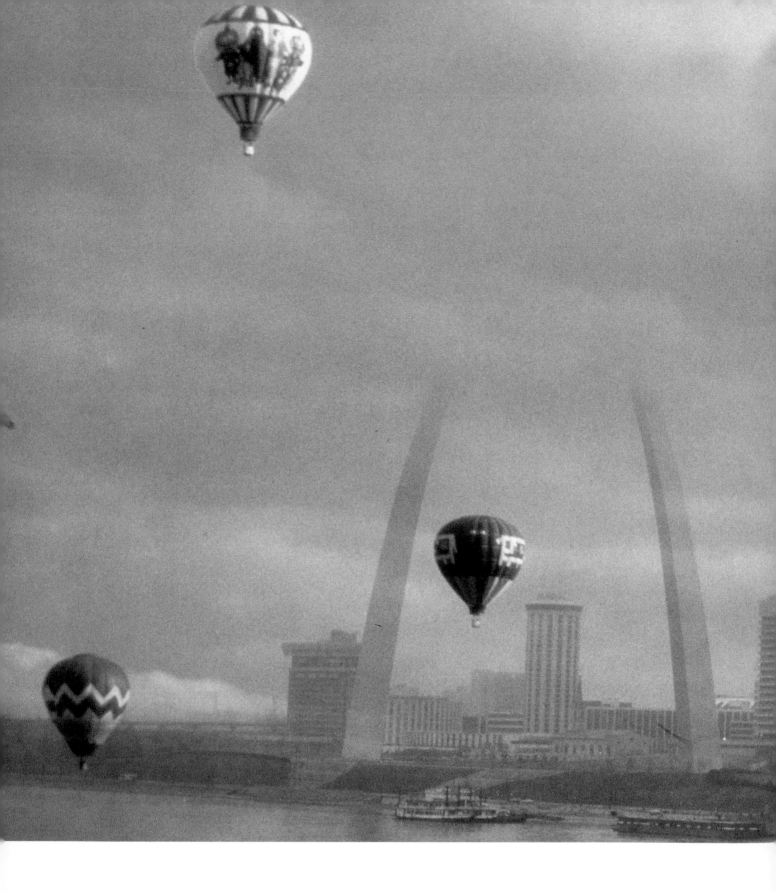

Text and selection copyright © 1989 by
The Curators of the University of Missouri
All rights to photographs are retained by the
photographers
University of Missouri Press, Columbia, Missouri 65211
Printed and bound in Hong Kong

For CIP data, see p. 128.

∞™ This paper meets the minimum requirements of
the American National Standard for Permanence of
Paper for Printed Library Materials, Z39.48, 1984.

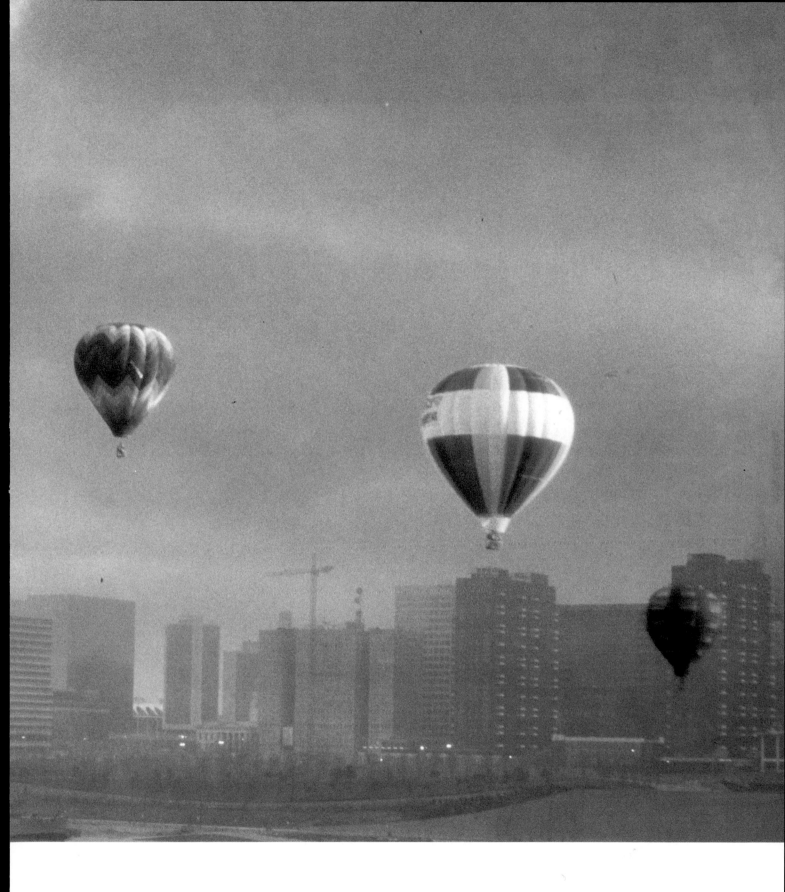

Front matter illustrations: p. 1, Gospel singers at Morton D. May Amphitheater during the VP Fair, by Robert LaRouche; p. 2, Old Courthouse, by Robert George; pp. 4–5, Skyline with balloons, by Leo H. Moult; p. 6, Civil Courts Building and Union Station at dawn, by James A. Cuidon; p. 8, Union Station clock tower, by Dan Johnson.

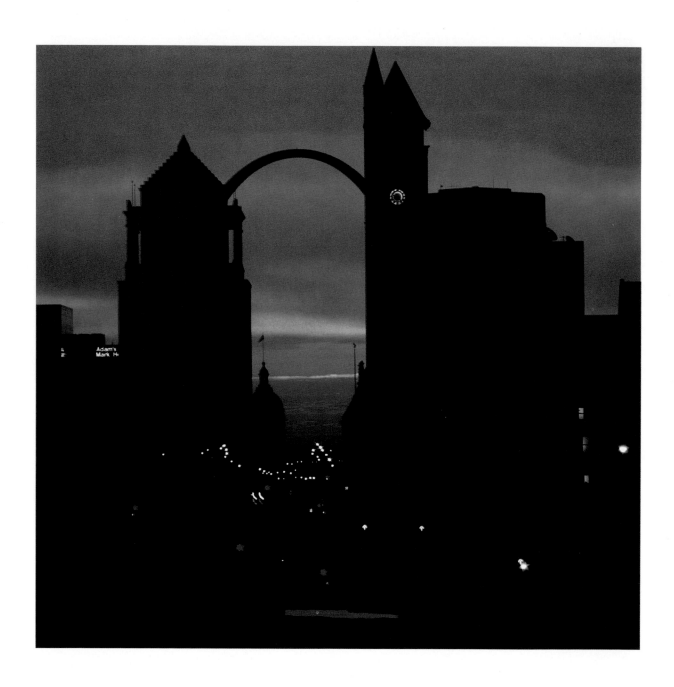

**For the folks who made
this book possible—
the people of St. Louis**

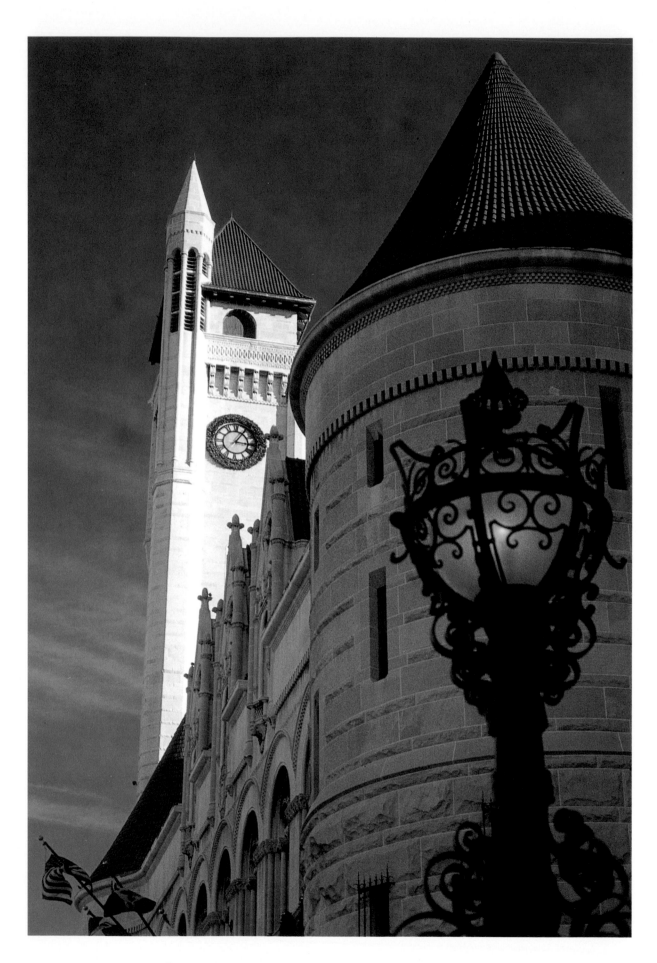

INTRODUCTION
by Elaine Viets

What is your image of St. Louis? An aging red-brick city? At first glance, St. Louis seems drab and dirty.

But this city is colorful. It has a colorful history, beginning with the French fur traders. To the great embarrassment of some of her highly proper descendants, Madame Chouteau, one of the city's Founding Mothers, didn't marry her Good Friend and Founding Father. She had already had a husband back in New Orleans. But he beat her, and she wouldn't stand for it.

St. Louis has colorful people, from the tamale seller peddling those steaming, spicy delights on the street corner, to the cigar-chomping alderman in his baggy suit.

Even its landmarks are colorful. Take the Arch. St. Louis reveled in that great gaudy project. Unless you realize that, you will never understand how this sleek, sophisticated stainless-steel monument rose up out of the solid brick and stone city.

You don't just look at the Arch. You experience it. You stand at one shiny leg and feel its smooth steel skin. Then lie on the ground and look up until you're dizzy. It is dazzling in the sunlight. At night, the silver moonlight slides down its sides.

If you are brave, you will go down into the maw between its legs and take the train to the top. This is no trip for claustrophobics. The little train cars tip and rumble. You can see the Arch's insides through slits in their sides.

At the top, the Arch is narrow and sways slightly in a high wind. It is an eerie feeling to be 630 feet high and know there is nothing solid under you.

On the Fourth of July, the grounds around the Arch seethe with a million or more people for the VP Fair. No family picnics and fireworks for St. Louis—this city loves pageants, parades, and balloon races, and the VP Fair has them all.

The VP Fair is just the biggest city celebration. There are dozens of neighborhood festivals, street fairs, even alley parties. Each features the neighborhood cuisine: beer and bratwurst, barbecue, Italian sausage. St. Louis food is rich and strange.

From the Arch, this crescent-shaped river city turns its back on the Mississippi River and heads west.

Consider Downtown the city's living room, where some of its best things are put on display for visitors to see: Busch Stadium, the domed dignity of the Old Courthouse, the dirty stone splendor of City Hall.

But like many living rooms, it has an unused look. It's a fine place for festivals and offices, but the city gets down to the business of living elsewhere. It is divided into three areas: the West End, the North Side, and the South Side.

The North and South Sides were designed for the city's middle classes. The West End is for the rich. The North is black. The South is white. That is simple, and a little simple-minded. There are blacks in South St. Louis, and whites live North. Parts of the West End are far from rich. Both North and South St. Louis have fine houses and pockets of wealth.

But those divisions work politically, possibly because we believe they are true. And more important than the statistics, each area has its own attitude. Each area has its pride. The West End is proud of its old families, old history, and old money. The North and South each believe they secretly keep the city going and do the real work of the world.

Besides, this city loves order. Everything must be classified and put in its place.

When two St. Louisans meet, we ask each

other, "What school did you go to?" Not what college—what high school. We are too polite to ask rude questions like: "Does your family have any money? Is your father important? What's your religion?"

But in St. Louis, if you know what high school the person went to, you can have all those questions answered. For the record, I went to St. Thomas Aquinas. That's North County, blue collar, and Catholic.

This passion for order reaches fanatic extremes in the old German section on the South Side. There are neighborhoods where all the houses are brick, all the gutters are painted forest green, all trim is white, all concrete steps are gray. If you're not sure what to paint it, paint it white. The renegades who go for pink or blue trim live with the disapproval of their neighbors. They will still have the regulation aluminum awnings, geraniums and petunias in pots on the porch, concrete Virgins and twirling plastic sunflowers on the lawn.

Even the disorderly have their own order. Once I was walking on a disreputable city street with a pool shark. I was closest to the curb. He kept trying to take my arm and put me on his other side. I brushed him off. He looked exasperated and said, "Don't you know? Outside, the lady's for sale. Inside, the lady's for show."

Some of the city's finest architecture is in the West Central corridor. It starts with the grand houses in the West End with their carved fireplaces and stained-glass windows and grows more fabulous as it moves into Midtown.

There you see the gaudy Hollywood Byzantine of the Fox Theatre, with its golden idols on the ceiling, and its lions with flashing eyes on the grand staircase. Even the Fox's restrooms are wonderful. The men's room imitates Douglas Fairbanks' home, Falcon's Lair. The ladies' retiring room is done in the style of Mary Pickford's mansion, Pickfair. Liberace gave interviews in that ladies' room when he played at the Fox.

One thing I like about St. Louis: it doesn't just save its architectural charms for the rich and important. The ordinary homes on the city's North and South Sides have delightful details: brick arches at the windows, terra-cotta curlicues at the roof. St. Louis may have divisions among its people, but it is united in its beautiful architecture. That may be why it has one of the country's finest rehab movements. We appreciate the details the city lavished on us, and we want to save them.

Sometimes we even improve them. The Edison Brothers Stores' warehouse, at Highway 40 and 14th Street, could be the symbol of the new, rehabbed St. Louis. The warehouse was a dull brick building until it was turned into a trompe-l'oeil triumph by artist Richard Haas. On the flat brick surface, he painted fan windows, Egyptian obelisks, eagles, and the city's patron saint, King Louis, astride his horse. It is a stunning building. It is said that Haas's painted architectural details are so realistic, the pigeons try to land on the fake stonework and slide down the side of the building.

If that story isn't true, it should be. But this same sophisticated city also has a strong streak of prudery. That creates some entertaining controversies.

Take the Milles Fountain, across from the castlelike Union Station. It's difficult to believe its dramatic, delicate beauty was once the center of a nasty little fight in the 1930s. The fountain represents the meeting of the Missouri and Mississippi rivers. They meet, all right—as a couple of buck-naked river gods, attended by frisking water creatures. The spouting water veils most of their nudity.

That wasn't enough for the leaders of the fountain controversy. They wanted the nude figures to wear draperies, especially the male figure of the Mississippi. "We can't let our children see things like that," said a city art commission member, Hubert Hoeflinger. "The female figures aren't so bad, but I still think those male figures ought to be draped." The newspapers never tired of noting that Hoeflinger was a tailor, implying his profession wants to put everything in pants.

10

But art prevailed. The children of St. Louis got their chance to be corrupted, and the river gods still frolic undraped.

Both the North and South Sides have their share of great parks, fountains, and bandstands. St. Louisans love to come out for their summer concerts.

One night, I was at a band concert in Tower Grove Park, on the South Side. We sat next to a German gentleman and his dog. It was a black rottweiler with pretty brown patches over his eyes like thumb prints. His owner fed Otto peanut butter on crackers. When the concert started, Otto sat alert at his owner's side. Midway through, Otto got restless with the oom-pah. His owner took him firmly by the muzzle and said, "Pay attention, Otto."

He did.

The city's love of order and pageantry helps make St. Louis a great sports city. We breed fierce fans. In 1987, the year the baseball Cardinals won the pennant, a record 3,720,122 watched the games at Busch Stadium. The whole metro area has only 2.4 million people.

Excitement isn't confined to big-league ball. There's tense action at school ball games, where parents stand at the sidelines, yelling encouragement and biting their lips.

Ball games are only the start of St. Louis sports. We've bred stars in boxing, running, and tennis. The city's richest and most difficult game is polo. Soccer is cheap and tough; it requires only shin guards, a ball, and rubber bands. There's ice hockey, basketball, racquetball, handball, and rugby. Bumpers display the rugby players' braggadocio: "Rugby players eat their dead"; "Give blood, play rugby."

Sports lovers may be everywhere, but St. Louis changes as it gets to the suburbs. It grows progressively newer. The homes are less ornate and more expensive. The shopping districts give way to shopping malls. New highways are always being built; new condos are always going up.

But even the newest bedroom communities have a touch of the past: a historic farmhouse, a pioneer graveyard, or an old German church with a hand-carved altar.

The suburbs also share the city's love for the slightly wacky, like Woofie's hot dog stand with its slogan, "The Hot Dog with Dignity."

St. Louis County is full of surprises. There's Laumeier Sculpture Park. This is no hands-off museum. You can not only touch these colorful sculptures, but you can also walk on them, sit on them, lie down on the grass and admire their lines and shadows from odd angles.

In the far western part of St. Louis, where the suburbs are still being carved out of the countryside, you'll see nature close up. In suburban Chesterfield, some residents who are only a forty-minute drive from Downtown keep salt licks in their yards for the deer. In Manchester and Valley Park, people stop on their way to work to save lumbering turtles from being squished by speeders on the twisty country roads.

What do these suburbanites have in common with the city dwellers? Nothing—or so it seems at first. Many of them live, work, shop, worship, and go to school in their suburbs. But those new highways will carry them back to the city. On the Fourth of July you'll find them once more under the Arch, celebrating St. Louis.

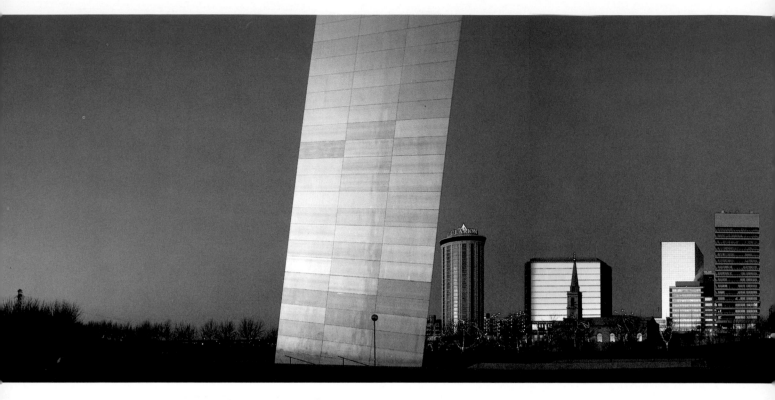

Gateway to the city. LEWIS A. PORTNOY

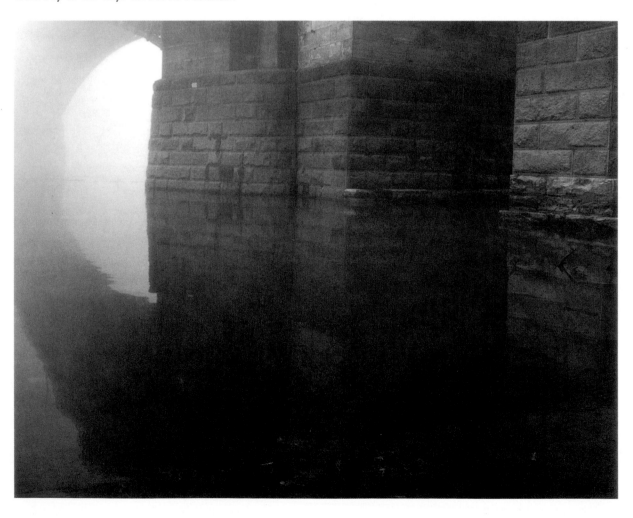

East abutment of Eads Bridge. QUINTA SCOTT

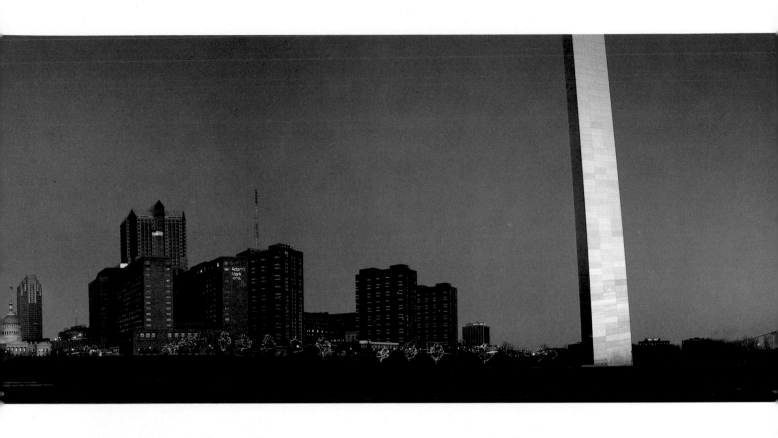

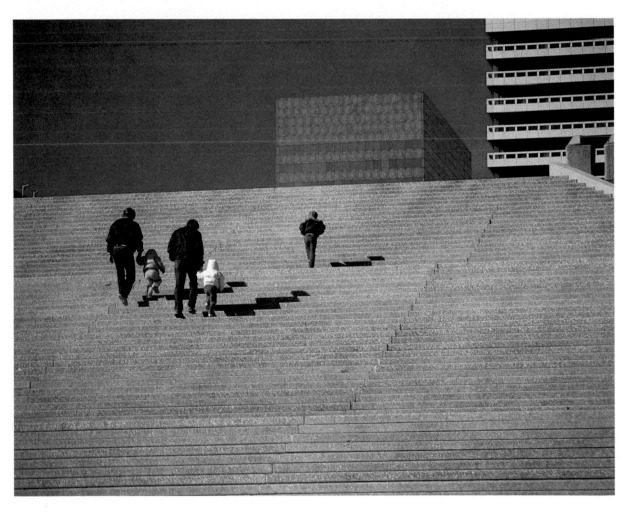

The Arch steps. MICHAEL L. RUDMAN

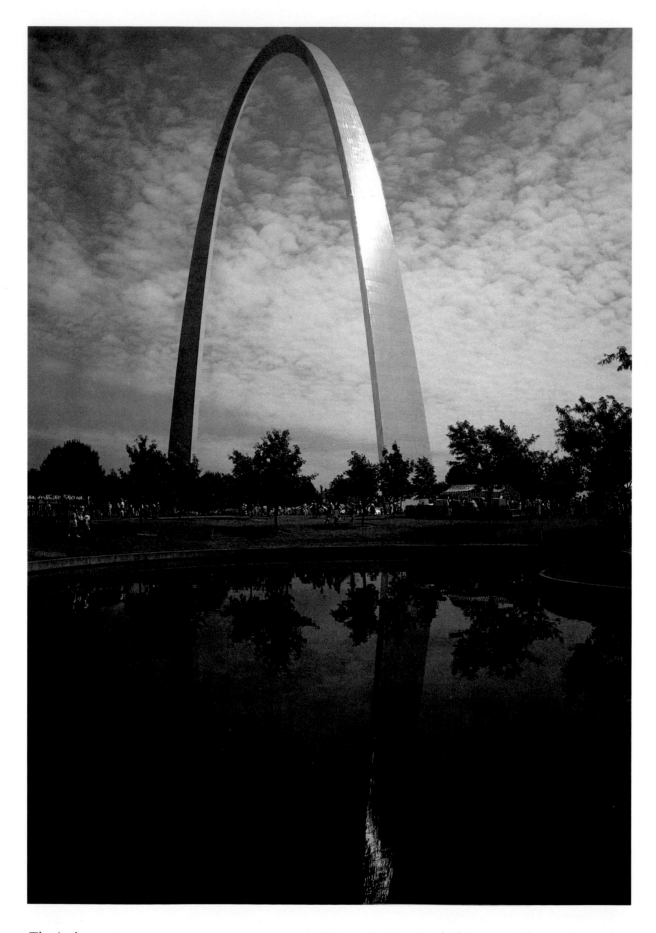

The Arch. WILLIAM K. LUEBBERT Morton D. May Amphitheater at night. JOHN DIGNAN

14

Overleaf: VP Fair crowd with Old Courthouse in background. JOHN DIGNAN

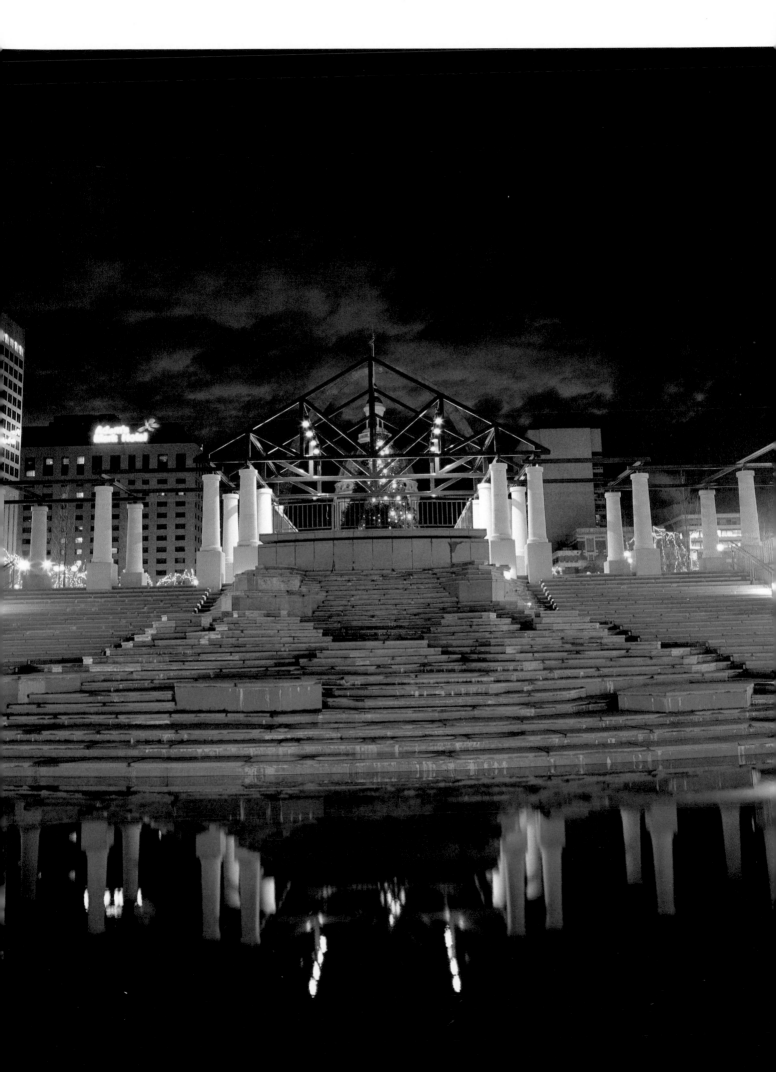

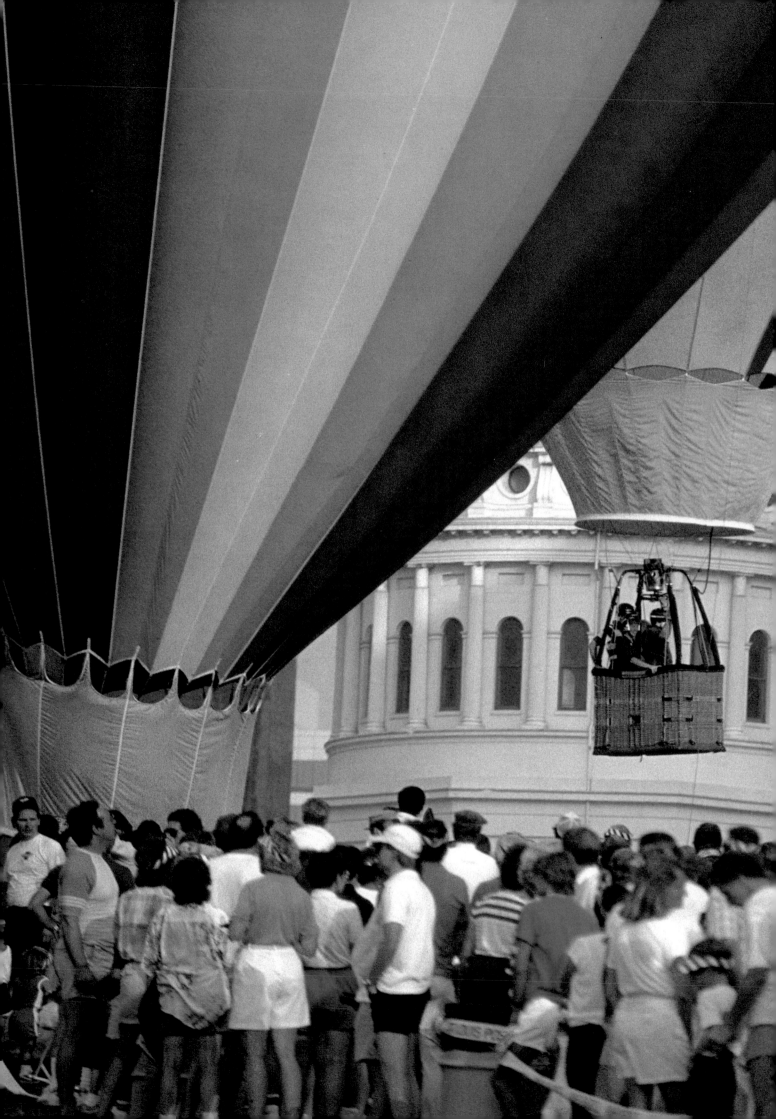

Ozzie Smith.
ROBERT GEORGE

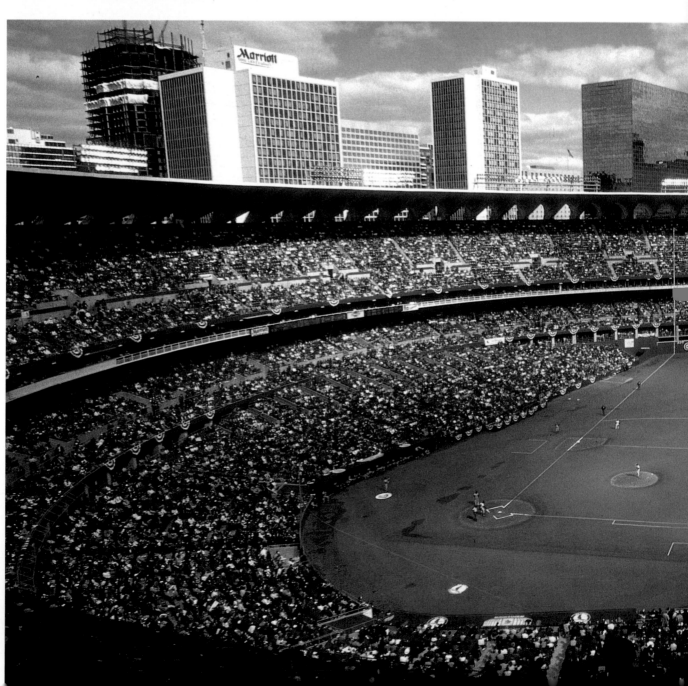

Busch Stadium. DAVID HINKSON

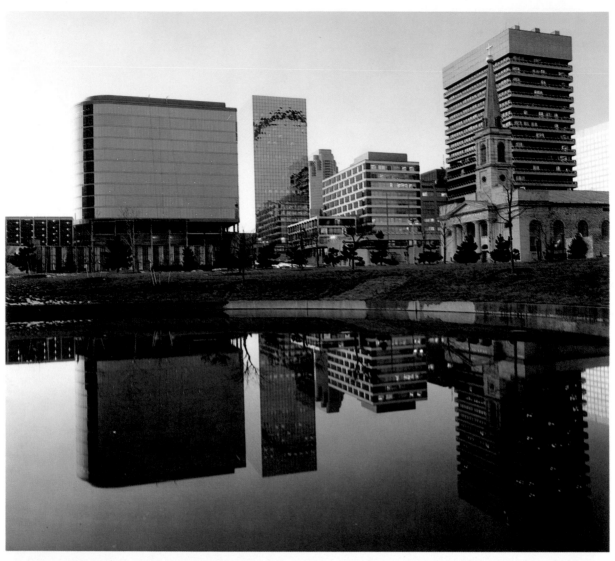

Cityscape with Old Cathedral. QUINTA SCOTT

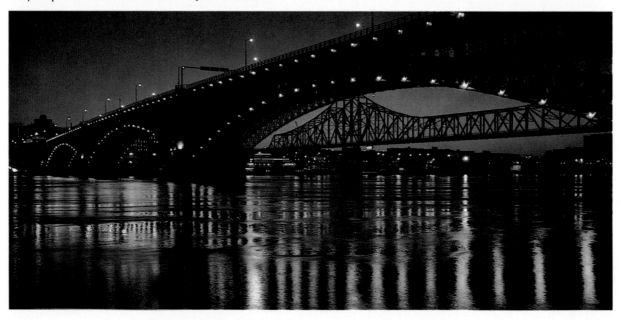

Eads and Martin Luther King bridges. JOSEPH V. MCKENNA

Old Courthouse in morning fog. THOMAS ZANT

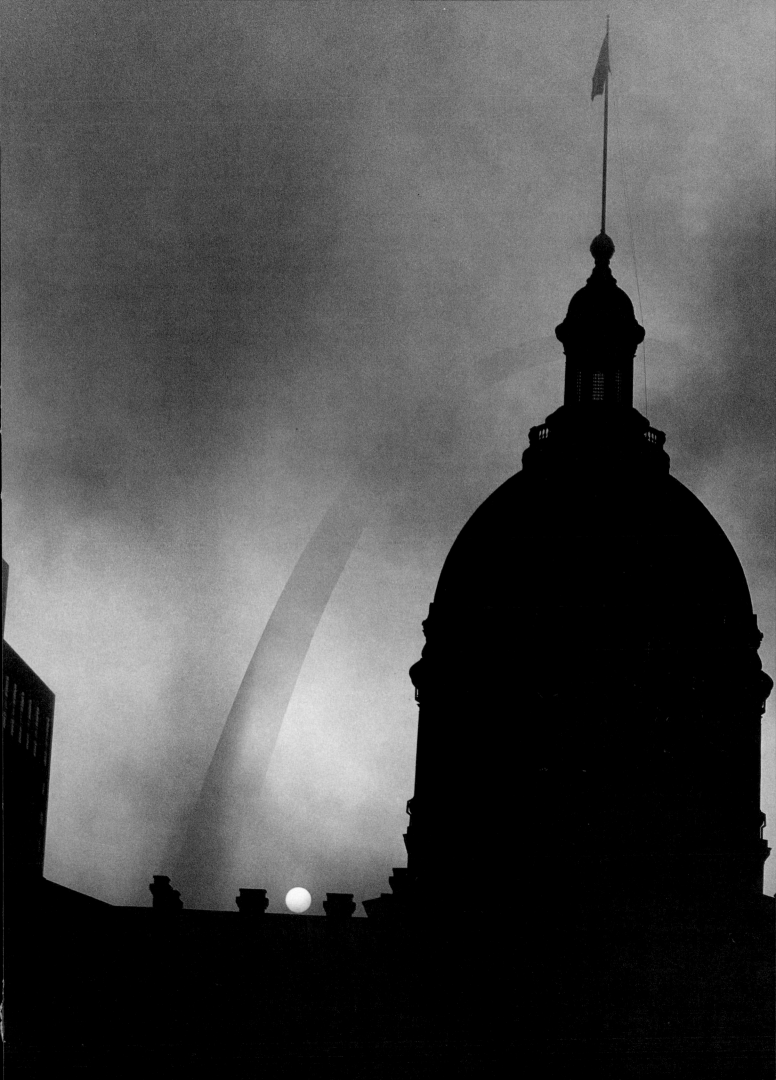

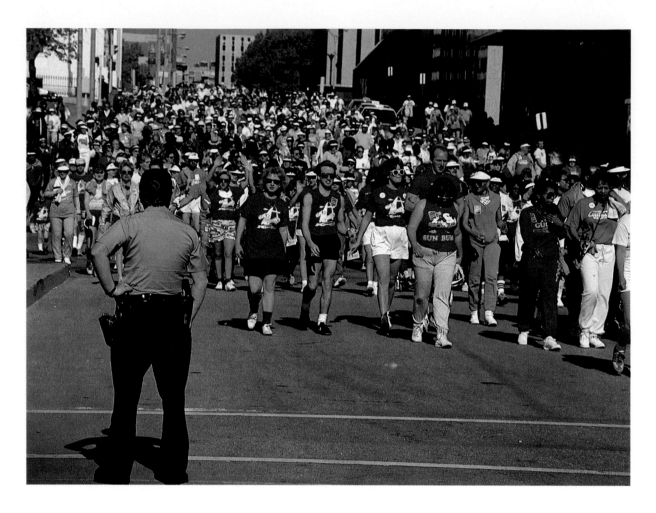

Walkathon passing Memorial Drive and Chestnut. ROBERT J. ROHLFING

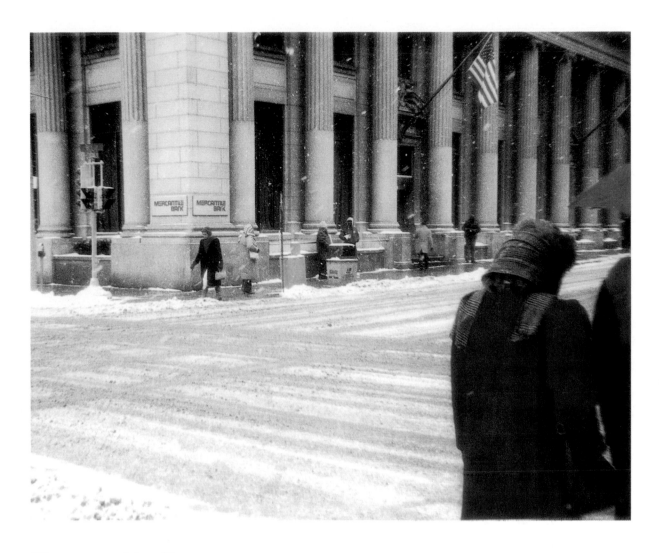

Winter scene at 8th and Locust. PATRICIA CURRIE

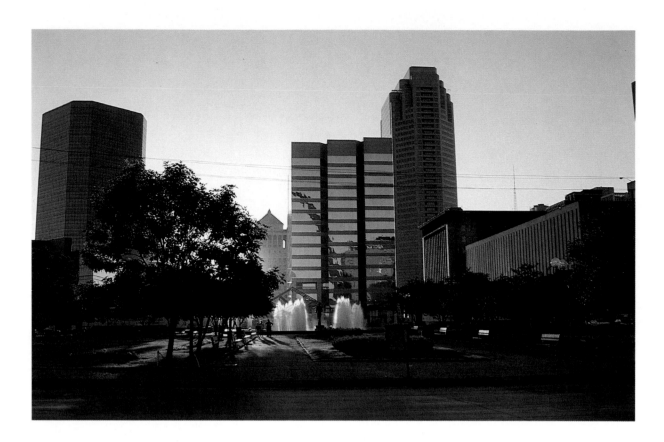

Kiener Plaza. JEFFREY LAWSON

Construction workers on Metropolitan Square. GARRY ROSE

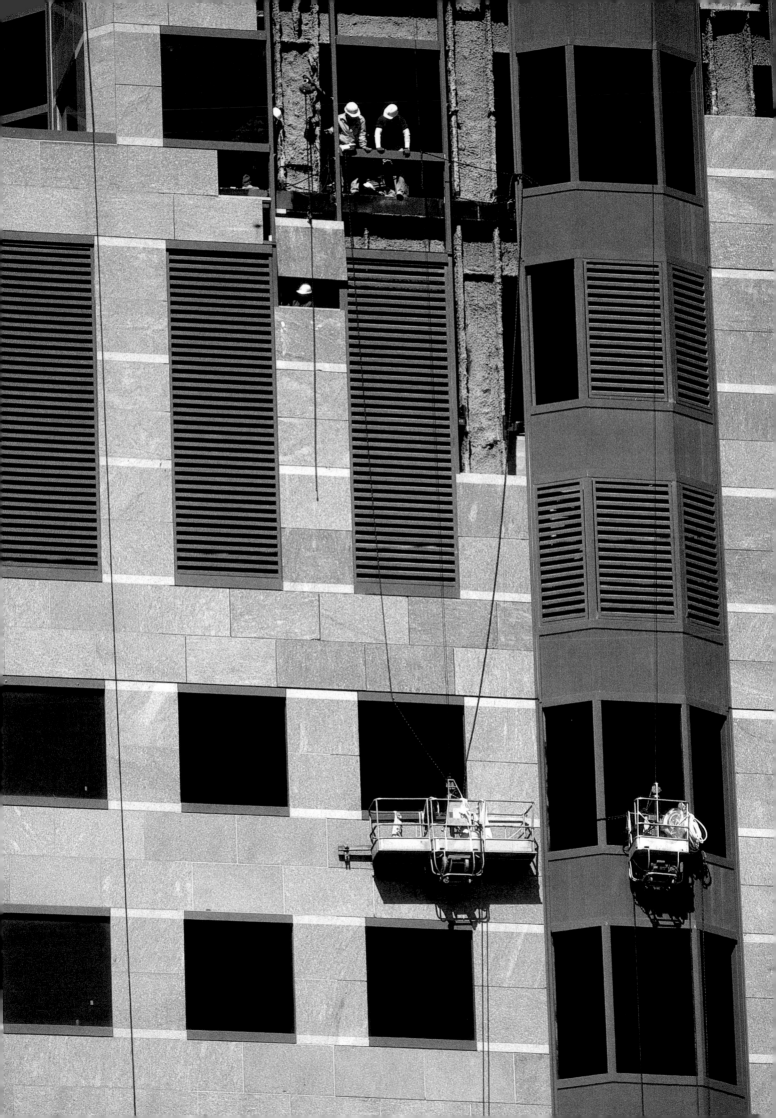

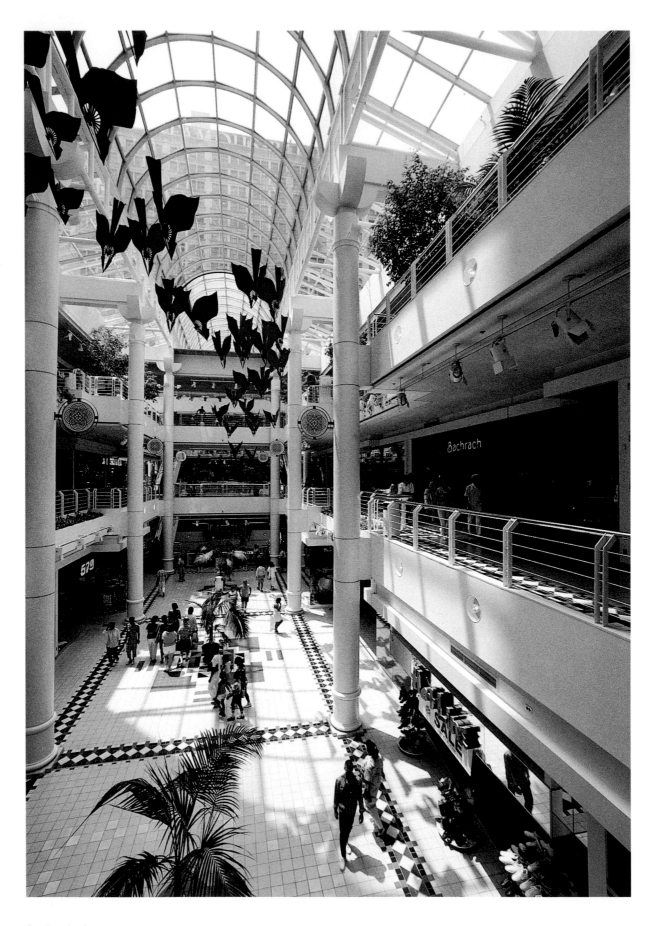

St. Louis Centre. LEWIS A. PORTNOY

26

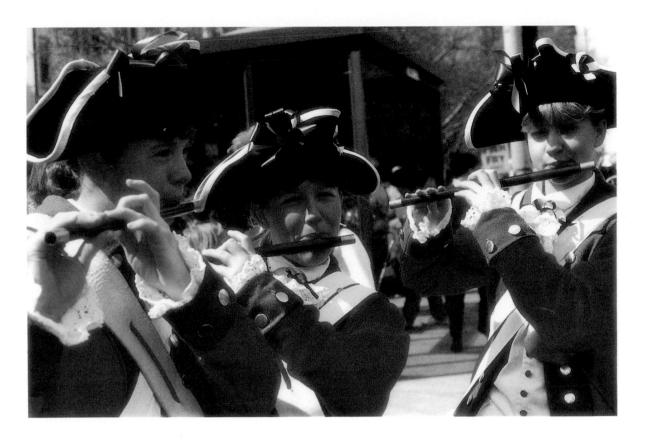

St. Patrick's Day parade. NAOMI RUNTZ

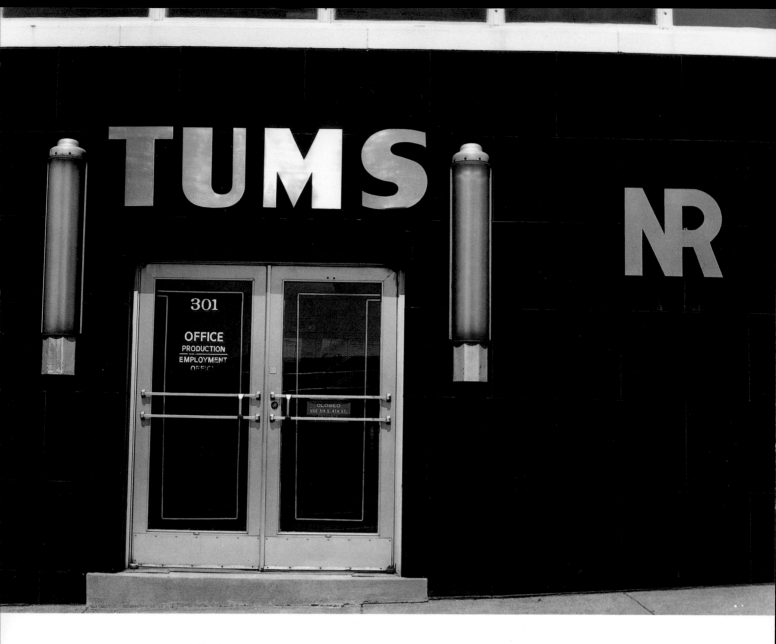

Doorway to Norcliff Thayer's Manufacturing Division. QUINTA SCOTT

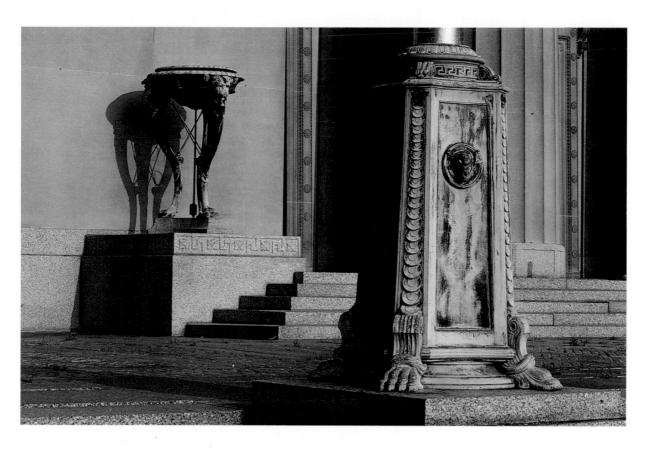

Outside the Civil Courts Building. GARY TETLEY

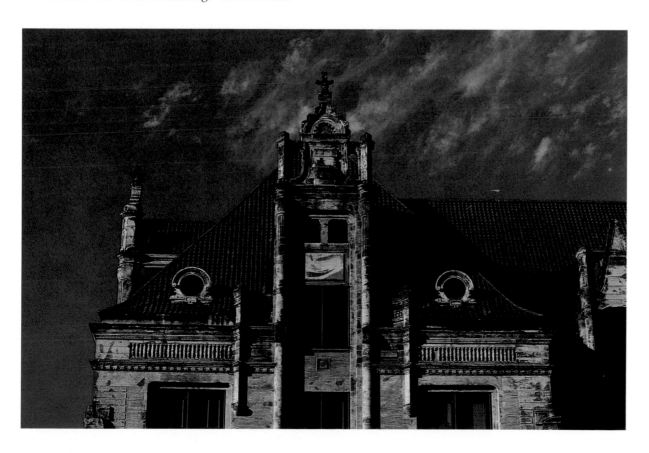

City Hall. GARY TETLEY

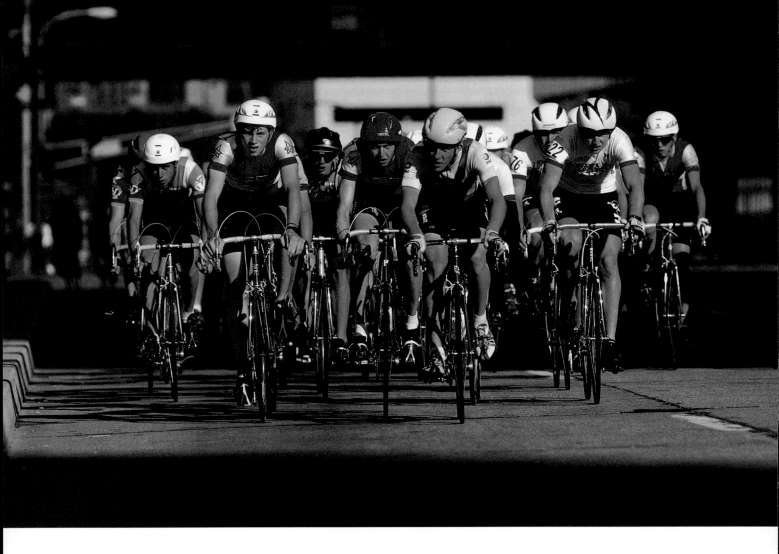

VP Fair Criterium. LEWIS A. PORTNOY

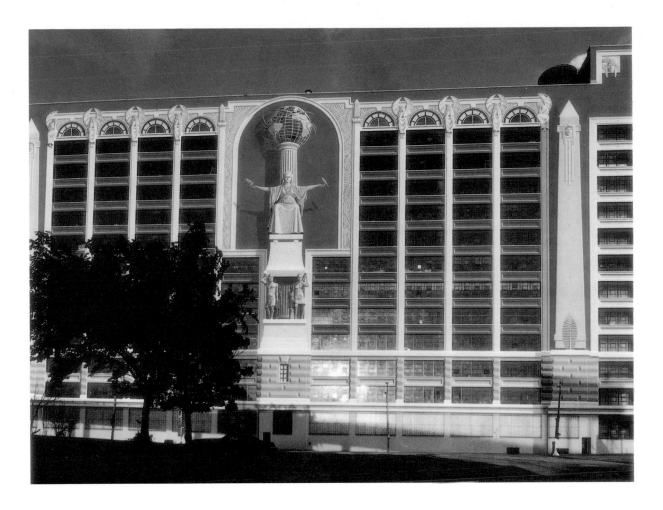

Edison Brothers Warehouse, west face, architectural murals by Richard Haas. QUINTA SCOTT

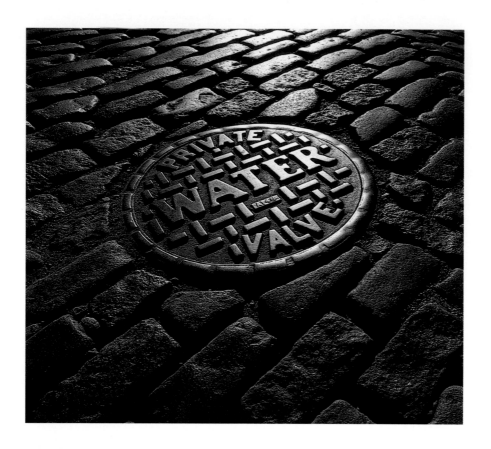

Water valve cover at Laclede's Landing. WILLIAM K. LUEBBERT

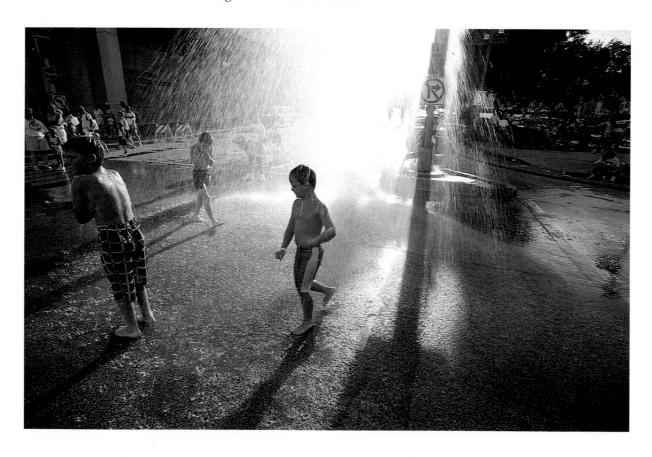

Shower, courtesy of the St. Louis Fire Department, during the VP Fair. DAVID HINKSON

Union Station and Milles Fountain. CHARLES MORGAN

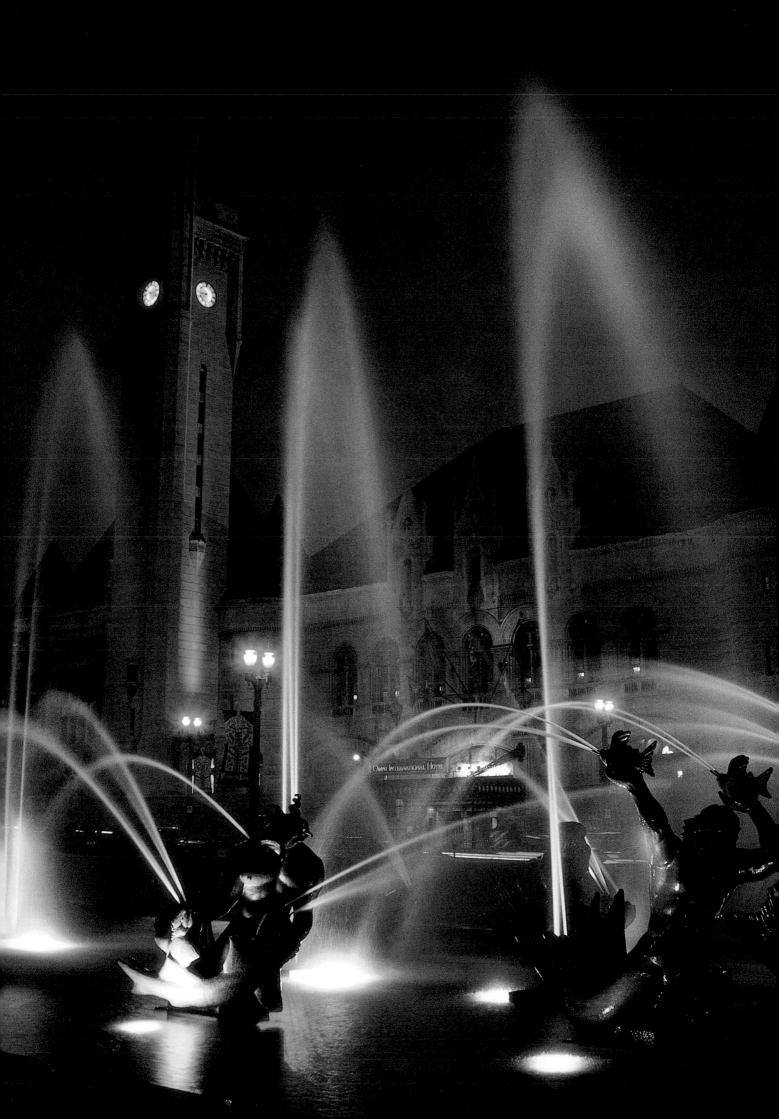

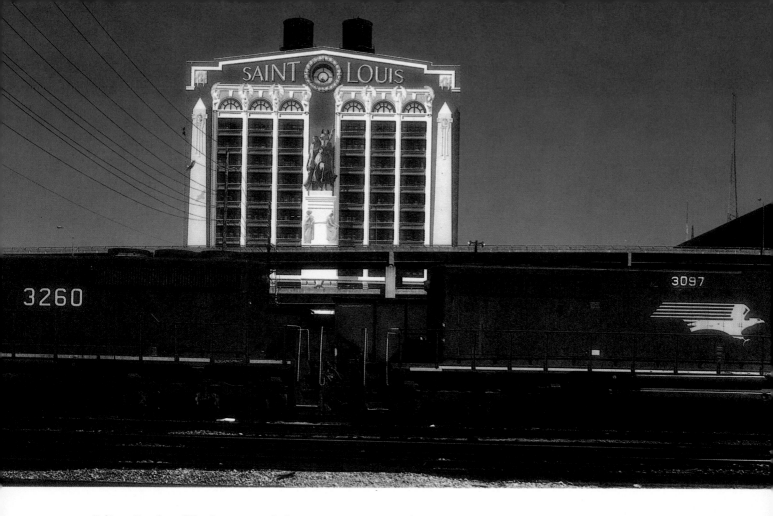

Edison Brothers Warehouse, south face. QUINTA SCOTT

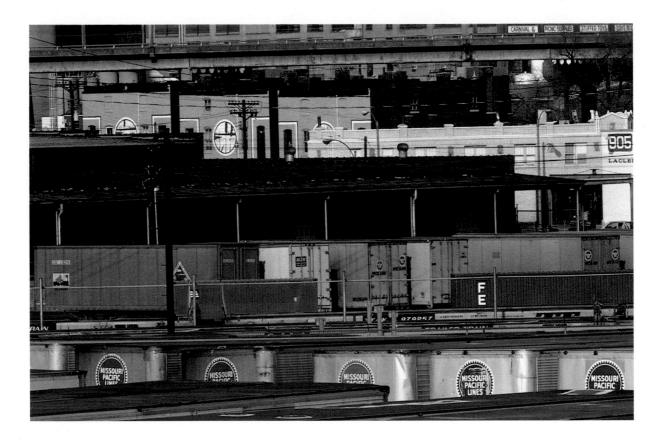

Rail yard at Chouteau and Spring. MARSHALL KATZMAN

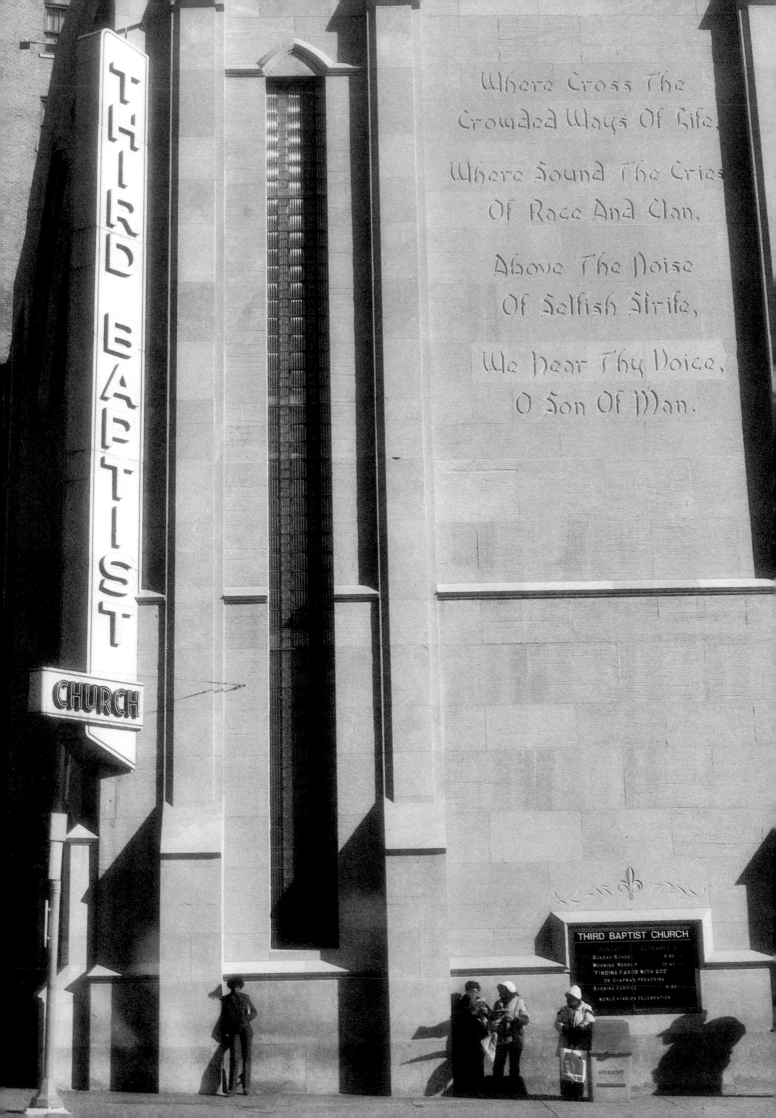

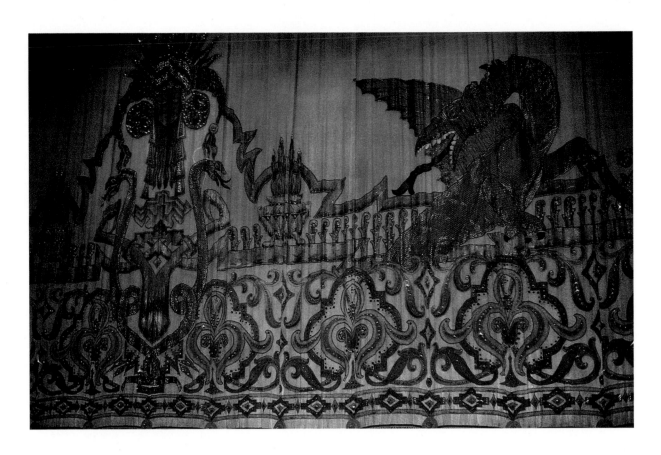

Original curtain at Fox Theatre. HELEN CALLENTINE

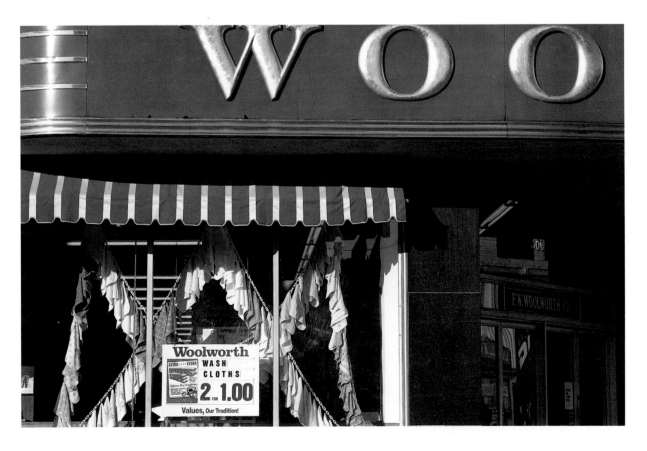

Woolworth's at Grand and Olive. CINDY WROBEL

Third Baptist Church at Grand and Washington. JIM SOKOLIK

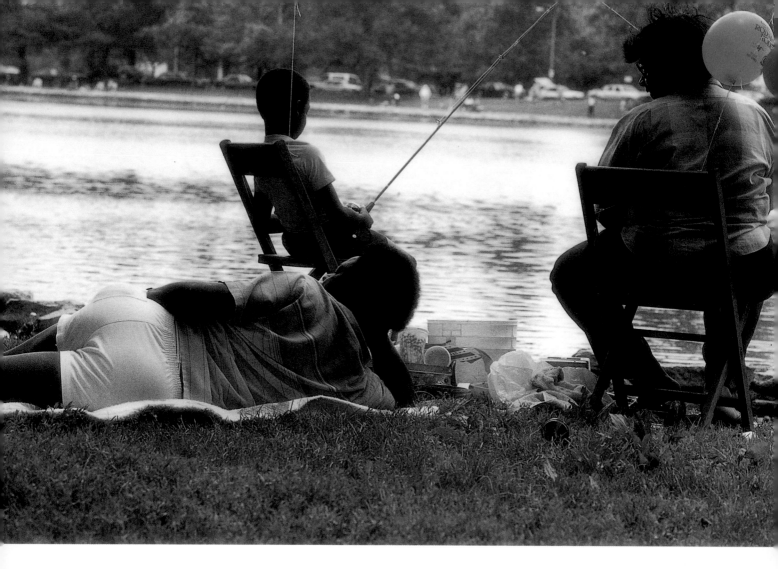

Family fishing in Forest Park. JIM SOKOLIK

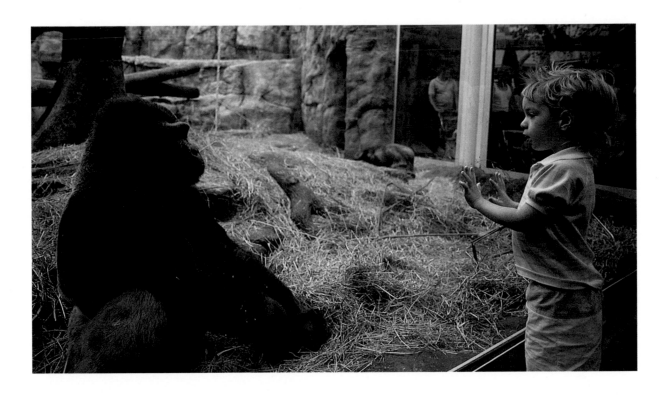

Jungle of the Apes at the Zoo. SHERRY LUBIC

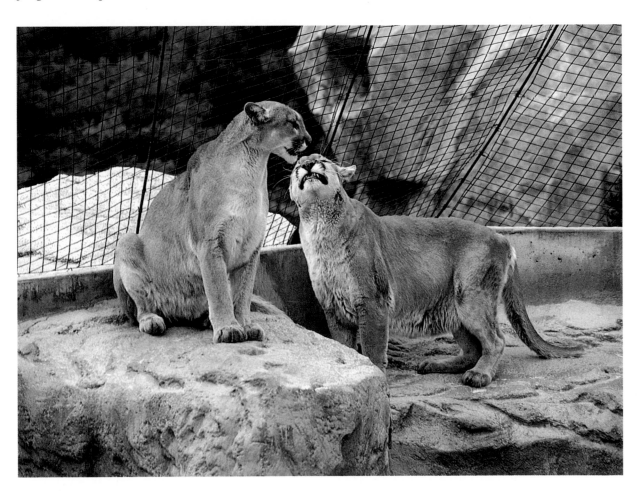

Pumas at the Zoo. LINDA SMITH

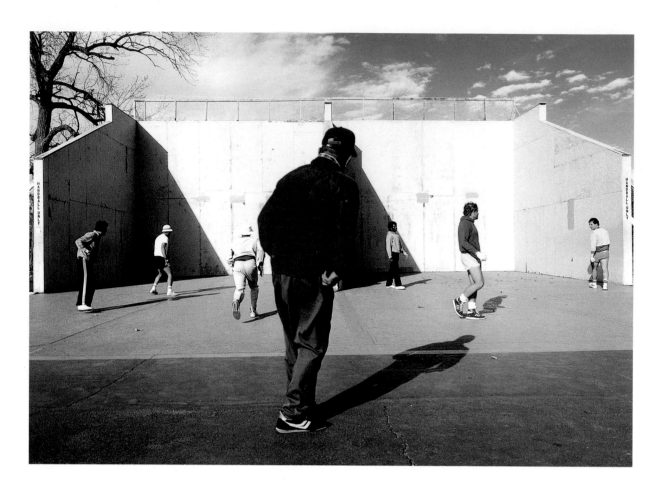

Handball courts in Forest Park. TOM PATTON

Rugby in Forest Park. LEWIS A. PORTNOY

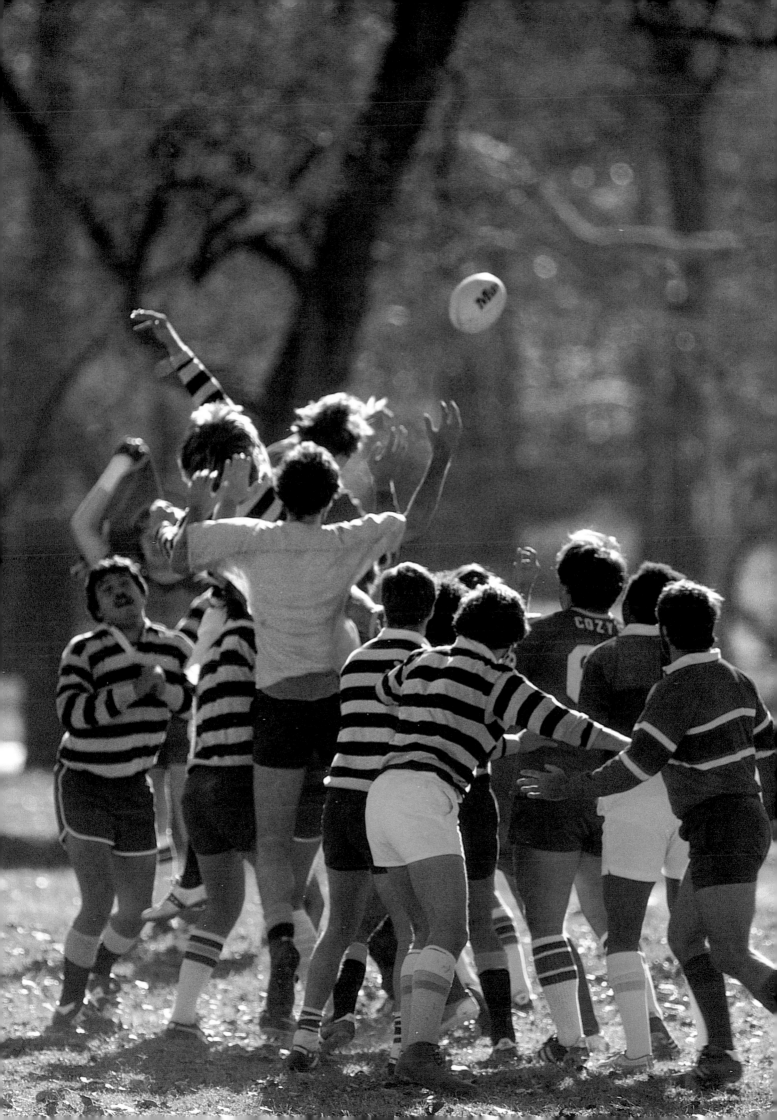

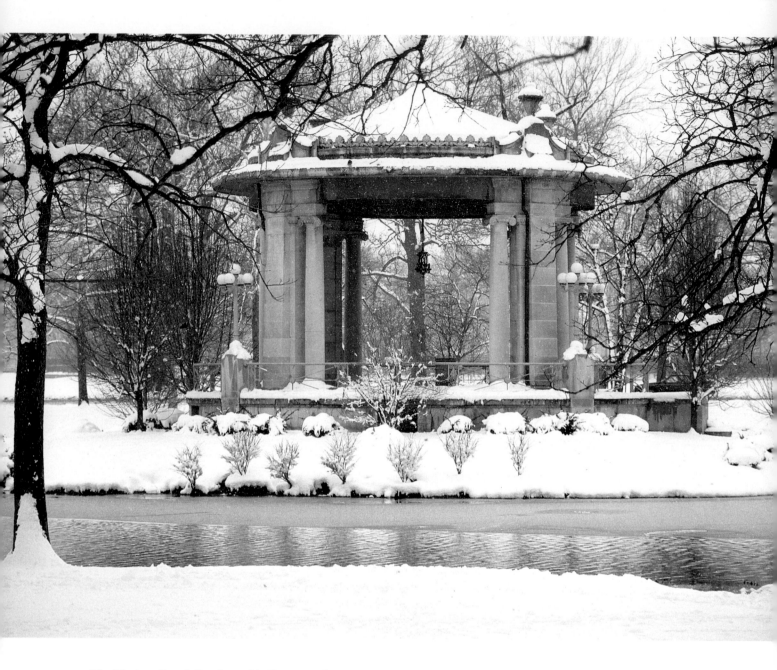

The Nathan Frank Bandstand in Forest Park. LEO H. MOULT

pp. 44–45: Muse outside Art Museum. QUINTA SCOTT

pp. 46–47: Art Museum. SCOTT SMITH

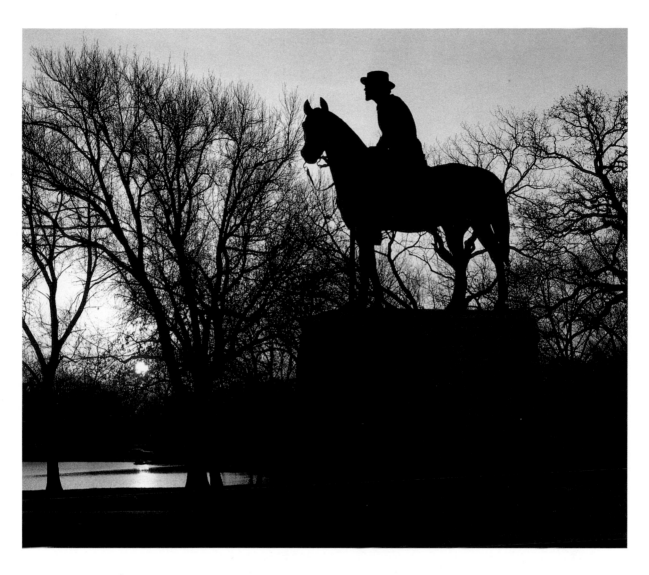

Monument to General Franz Sigel, Robert Cauer, sculptor. ERNST STADLER

Boathouse in Forest Park. SCOTT SMITH

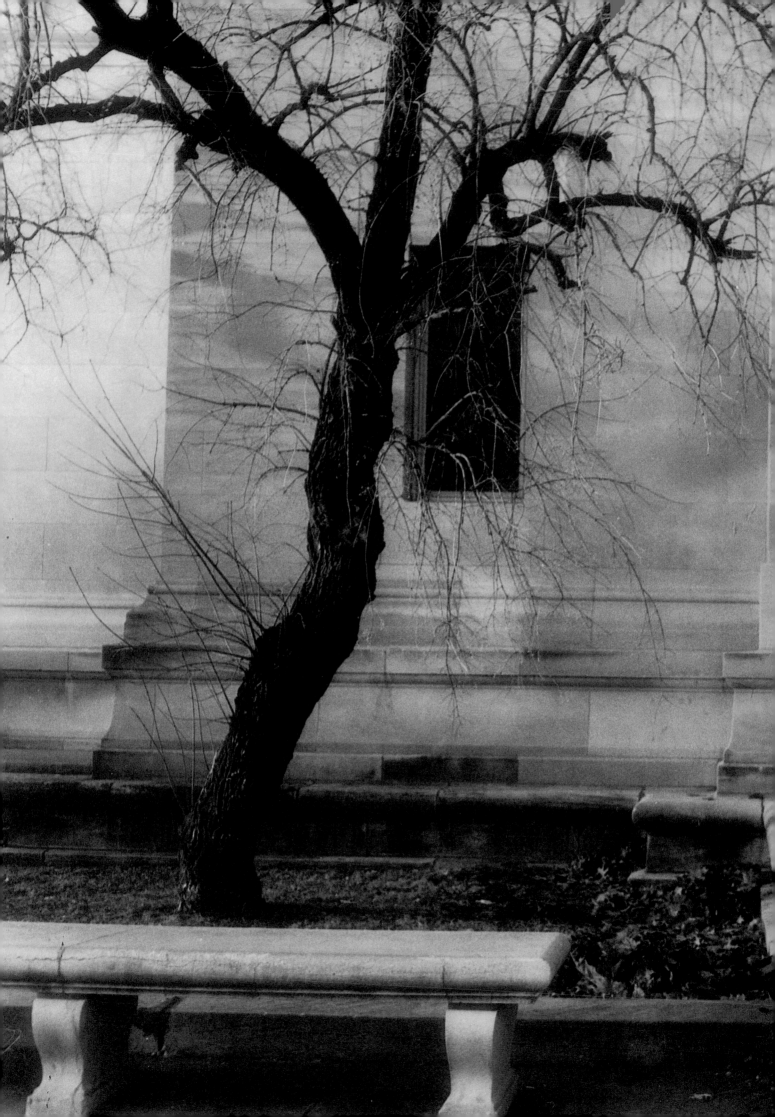

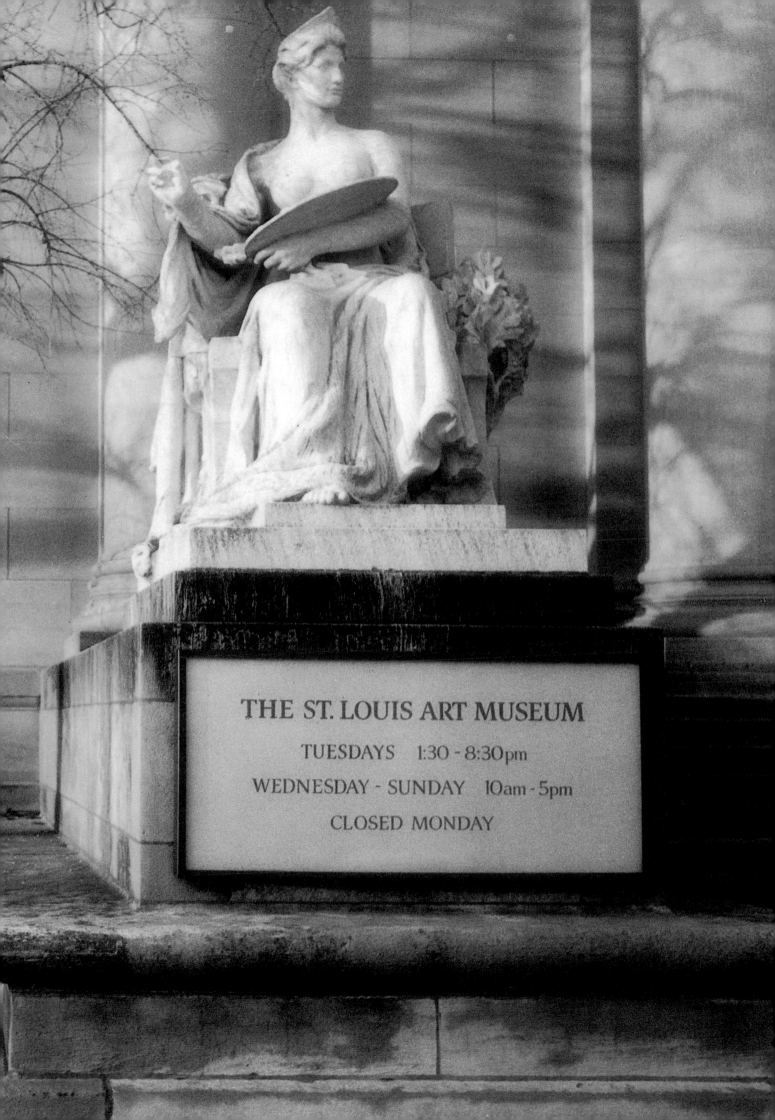

THE ST. LOUIS ART MUSEUM

TUESDAYS 1:30 - 8:30pm

WEDNESDAY - SUNDAY 10am - 5pm

CLOSED MONDAY

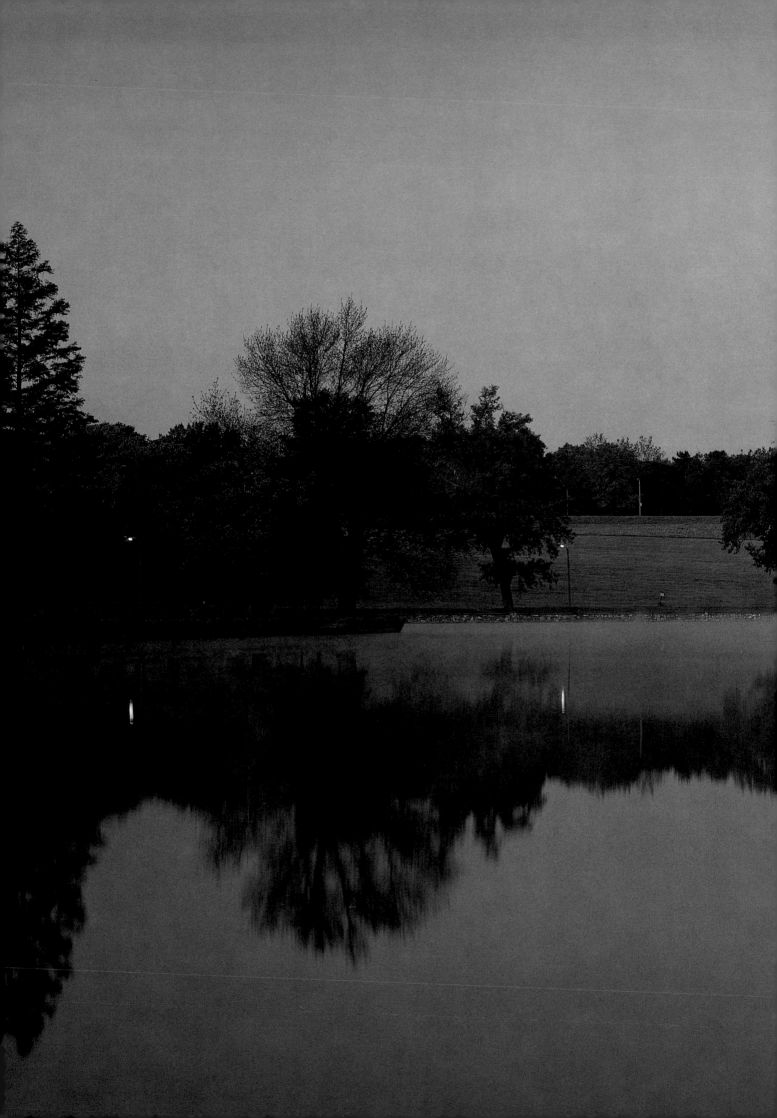

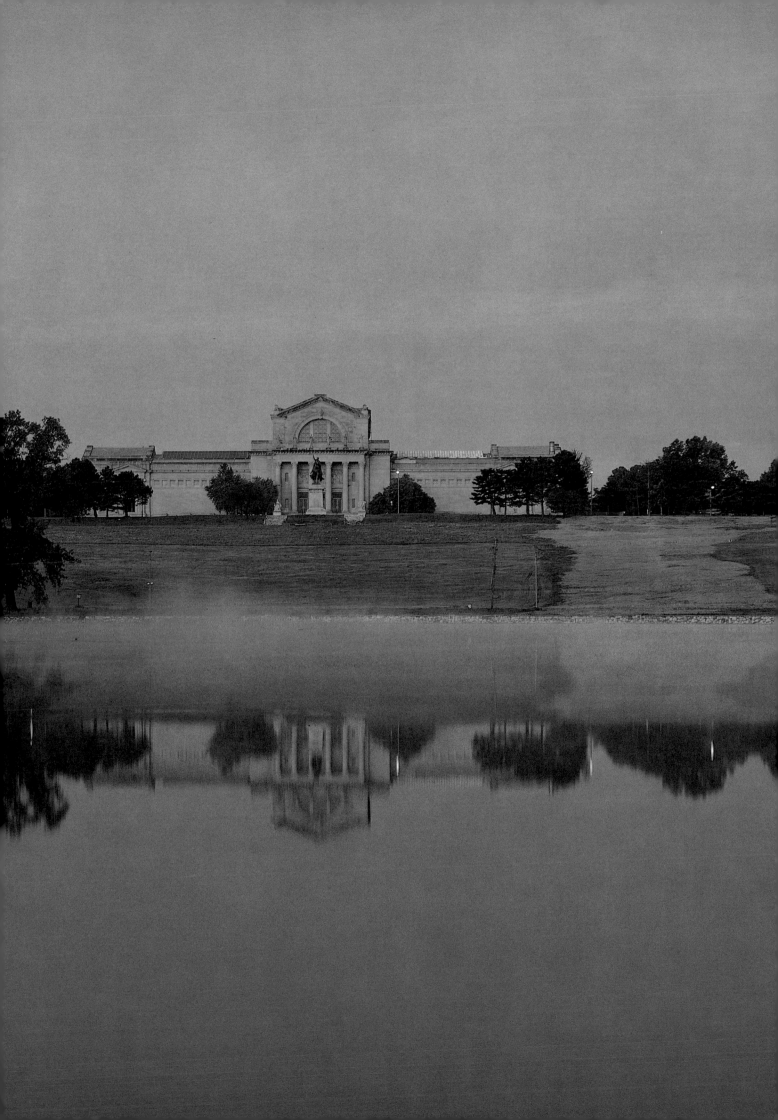

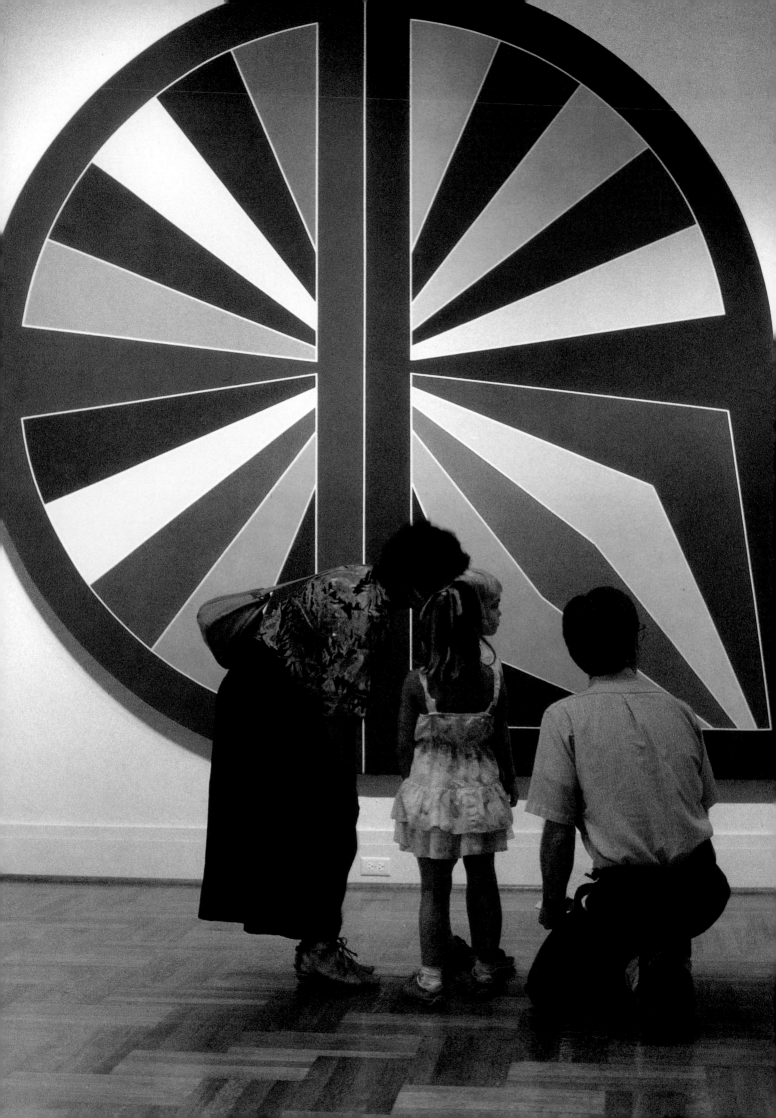

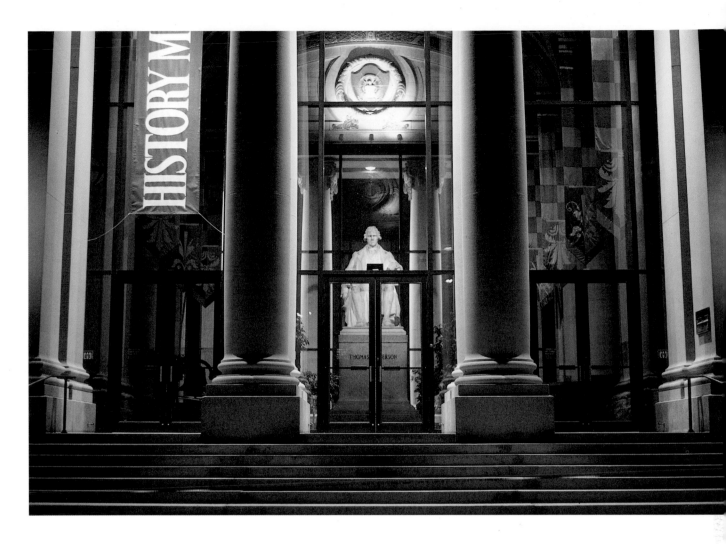

Thomas Jefferson at entrance to History Museum. JIM SOKOLIK

The Lamp (S2) by Frank Stella at the Art Museum. KRISTEN PETERSON

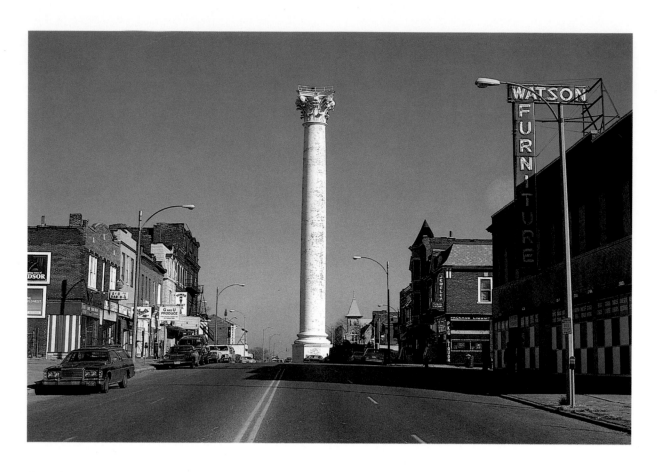

Grand Avenue Water Tower, George I. Barnett, architect. JIM SOKOLIK

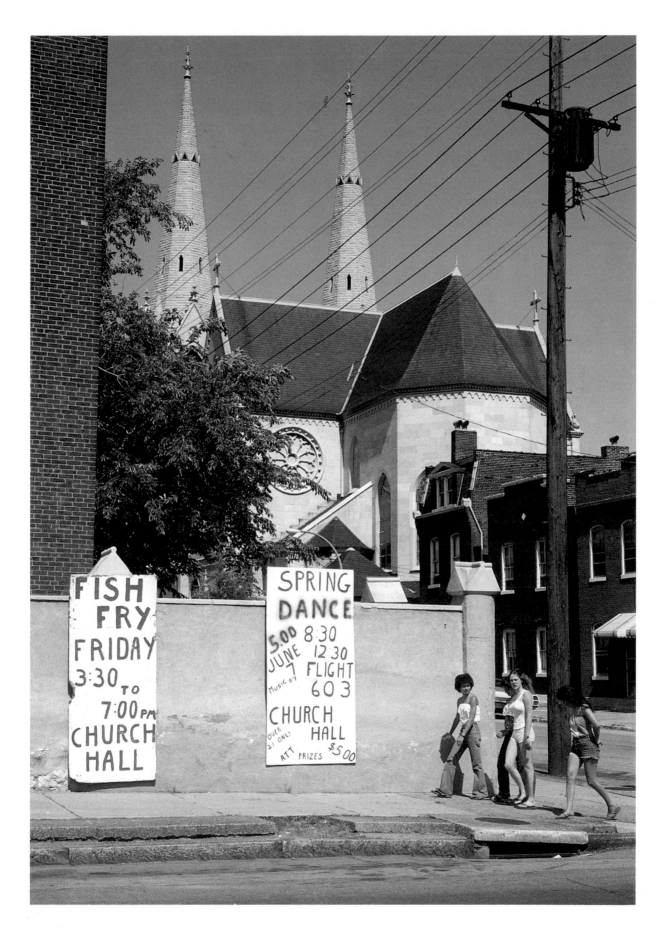

Hyde Park neighborhood. ROBERT LAROUCHE

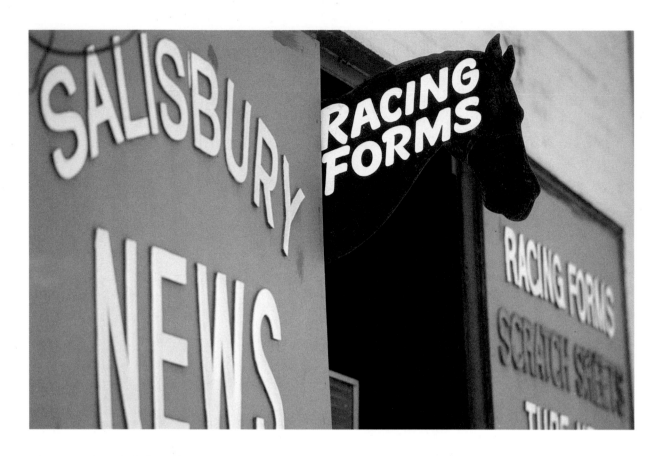

Newsstand on Salisbury Street. ROBERT LAROUCHE

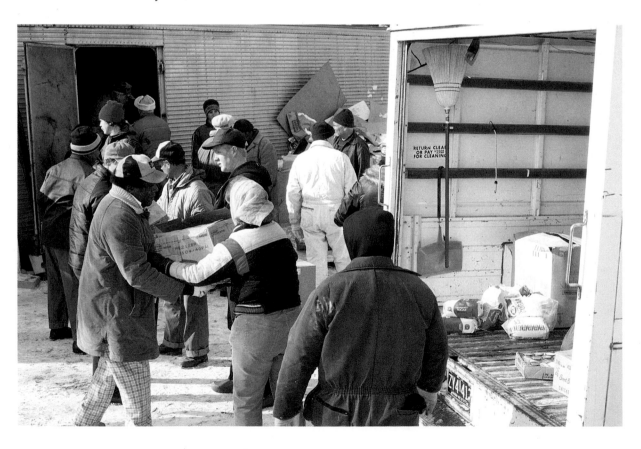

Food distribution at Someone Cares Mission on Benton Street. ROBERT LAROUCHE

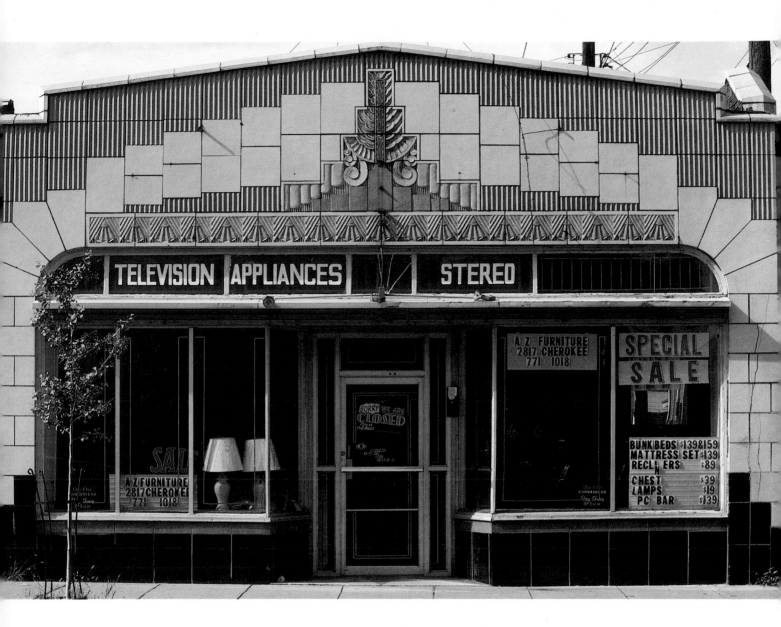

Storefront on Cherokee Street. GARY TETLEY

Overleaf: Soulard meat market. CINDY WROBEL

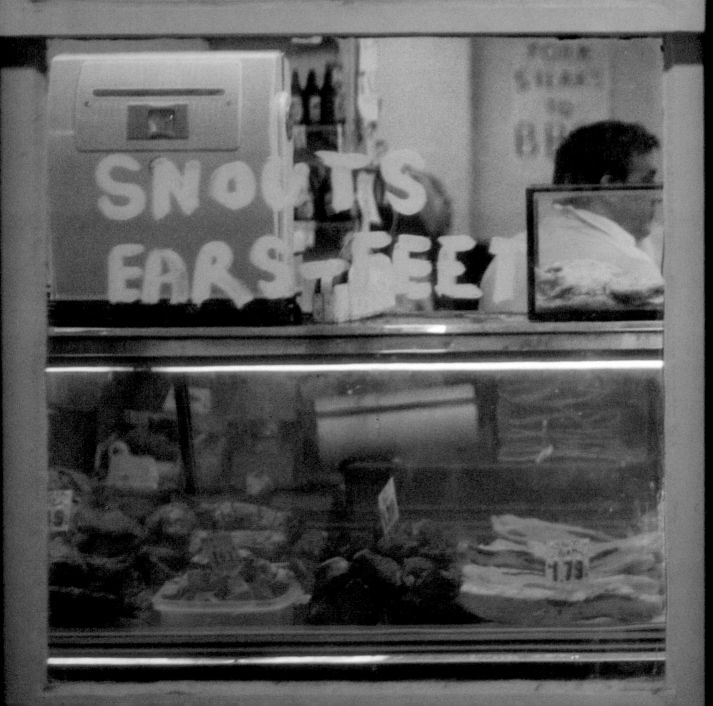

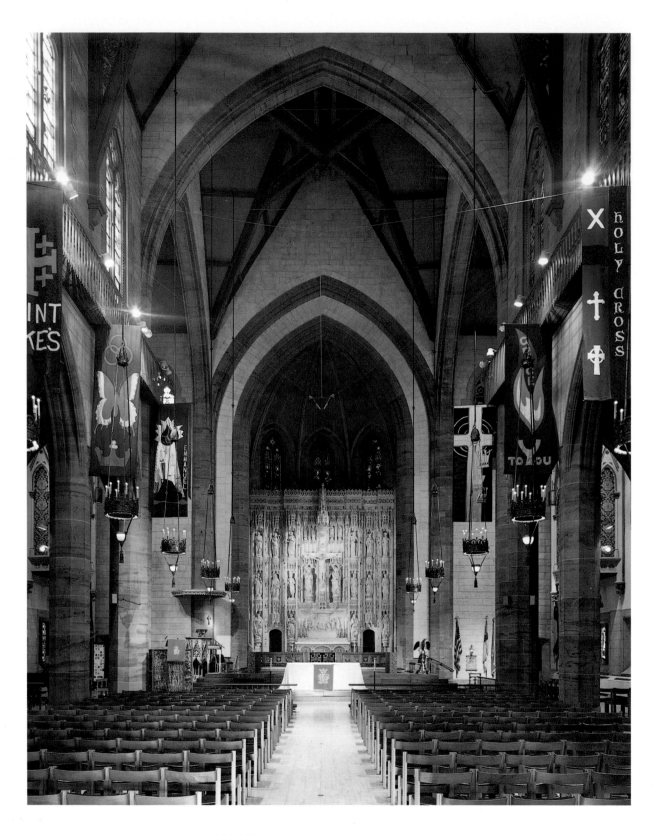

Christ Church Cathedral, Leopold Eidlitz, architect. QUINTA SCOTT

Benton Park. ROBERT LAROUCHE

56

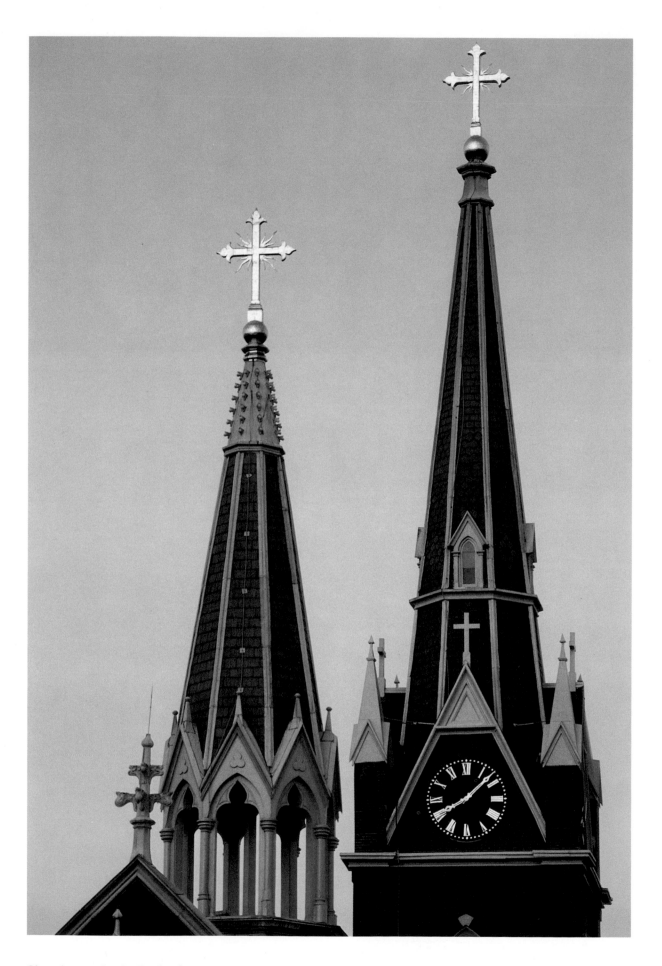

Church steeples in Soulard. JIM SOKOLIK

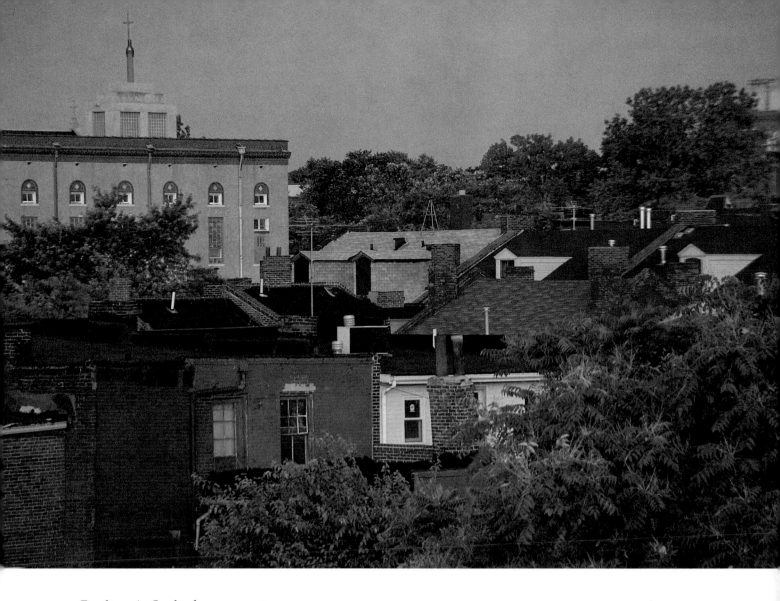

Rooftops in Soulard. J. MICHAEL TODD

Overleaf: Detail of Wainwright Tomb, Louis Sullivan, architect, in Bellefontaine Cemetery. GARY TETLEY

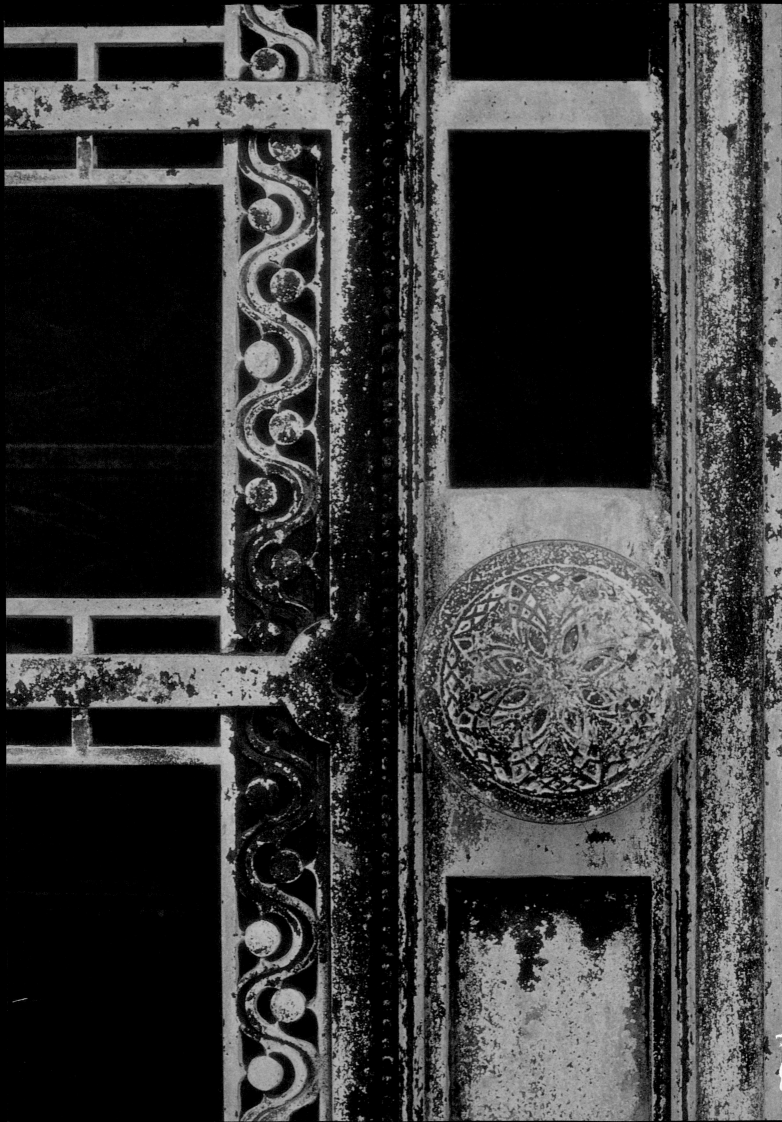

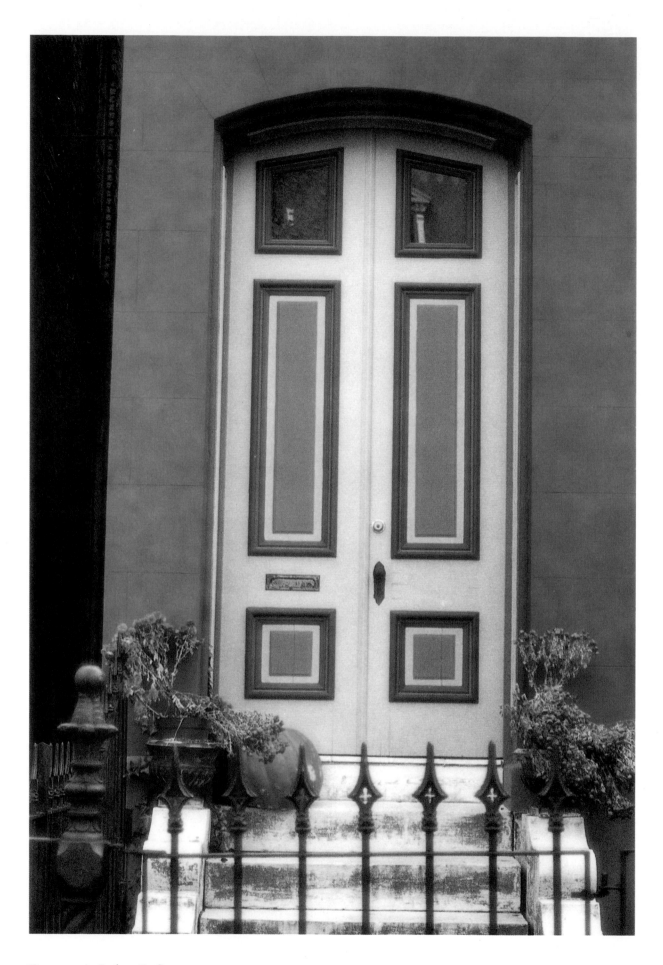

Doorway in Lafayette Square. ELIZABETH CROSBY

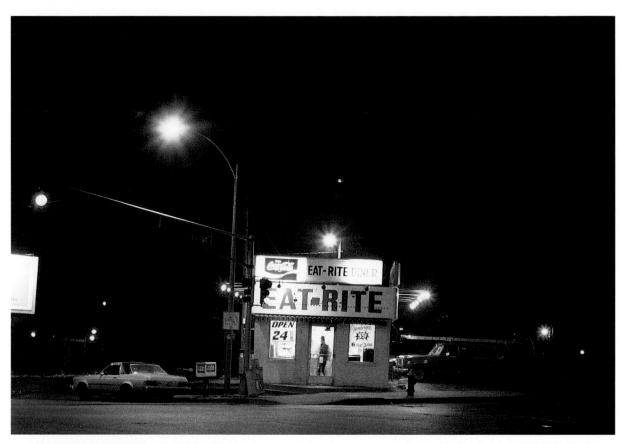

Diner on Chouteau. ROSE ANN HAEUSER

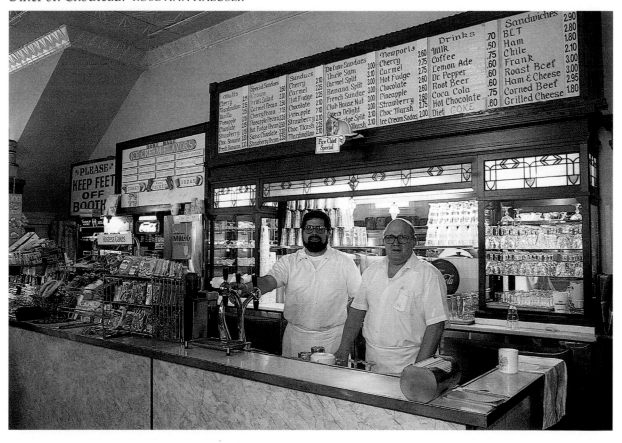

Mike and George Karandzieff at the Crown Candy Company. JIM SOKOLIK

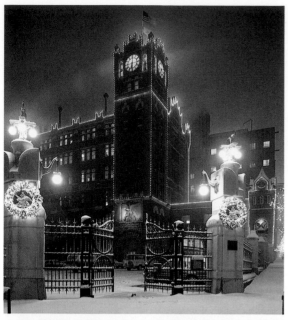

Brew House at Anheuser-Busch Brewery.
LEWIS A. PORTNOY

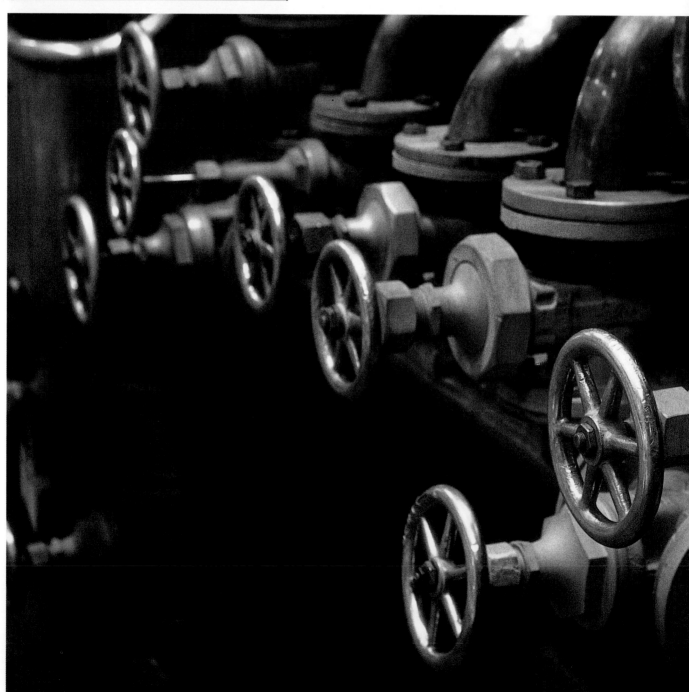

Valves at Anheuser-Busch Brewery. PETER J. GLASS

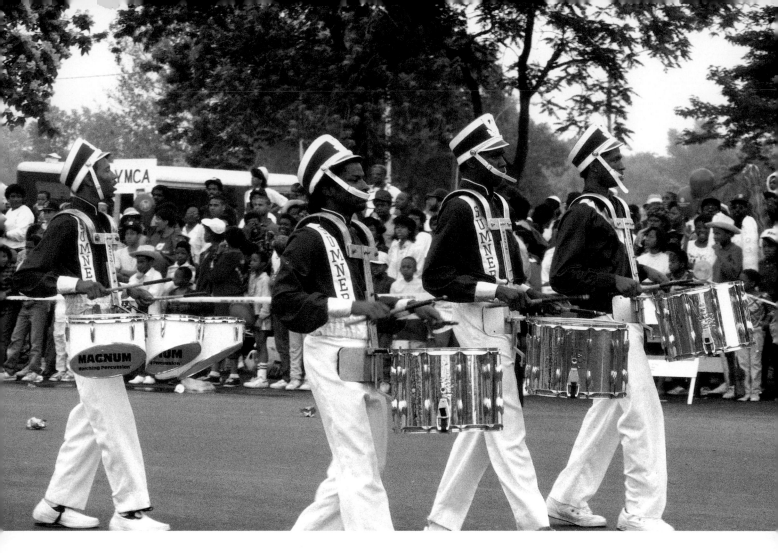

Annie Malone parade. BOB WILLIAMS

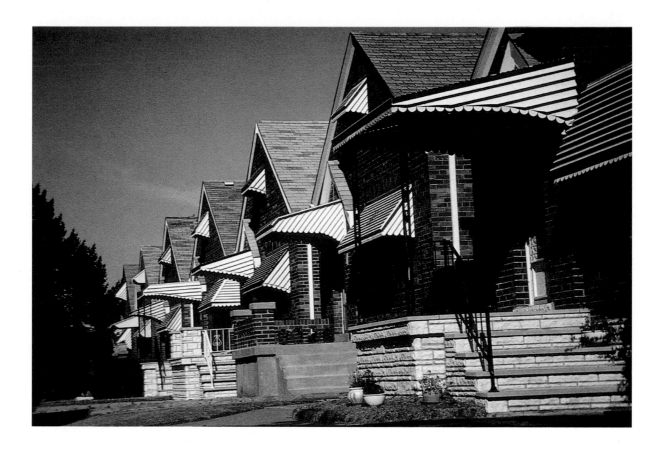

Jamieson Avenue. LINCOLN CROSBY

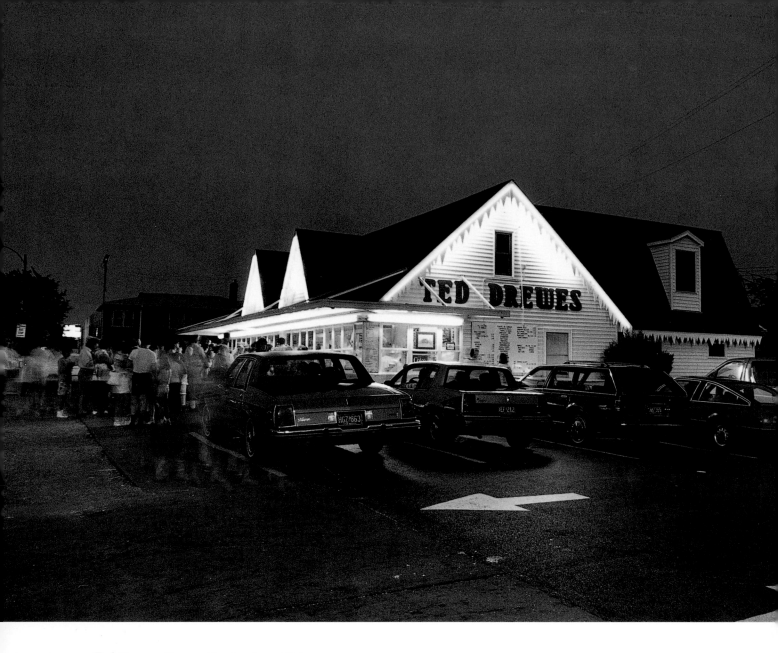

Ted Drewes Frozen Custard, on Chippewa. CATHY FERRIS

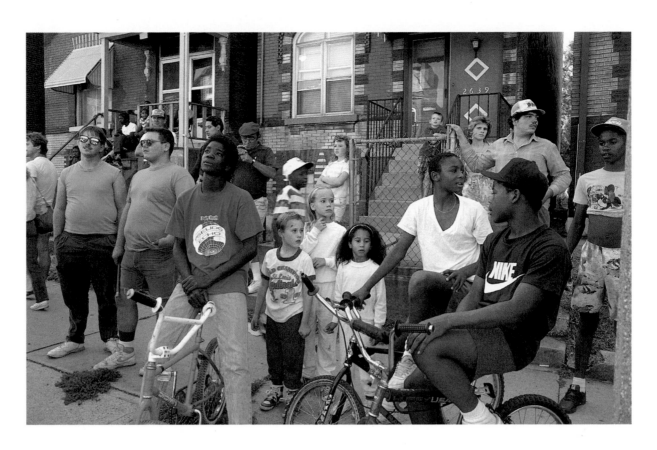

Crowd in DeSales neighborhood. ROBERT LAROUCHE

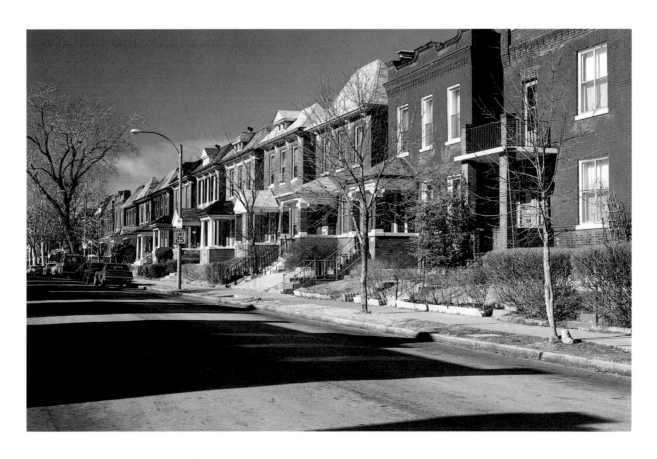

Lexington Avenue near Vandeventer. JIM SOKOLIK

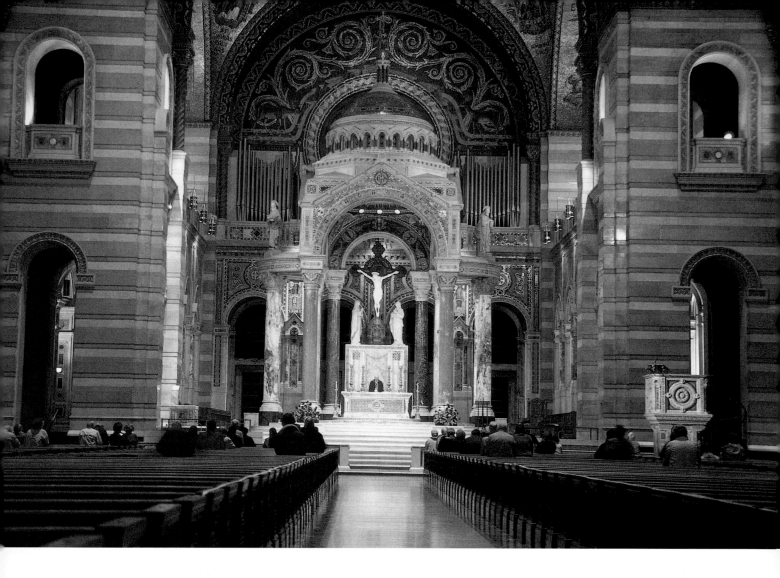

Morning Mass, St. Louis Cathedral. PAUL MARSHALL

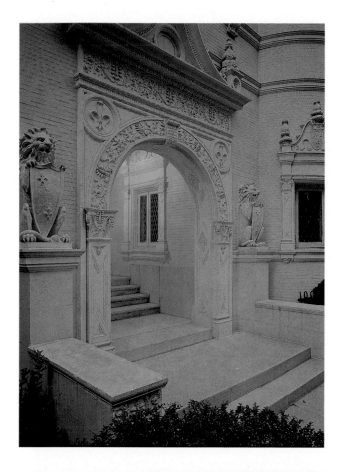

Doorway on Portland Place. ROBERT PETTUS

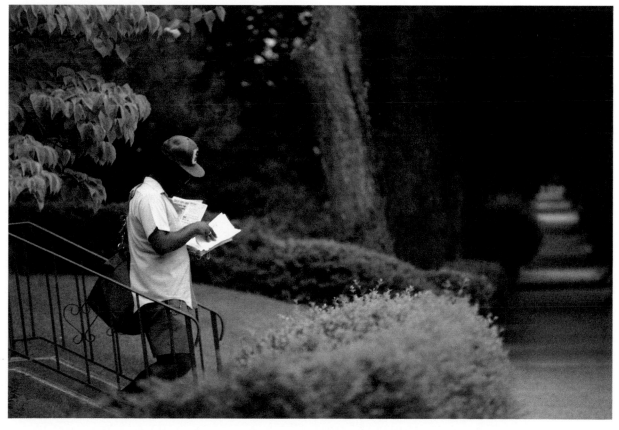

Mail delivery in the Central West End. KATHLEEN M. O'DONNELL

Overleaf: Japanese Garden at Missouri Botanical Garden. CAROL KANE

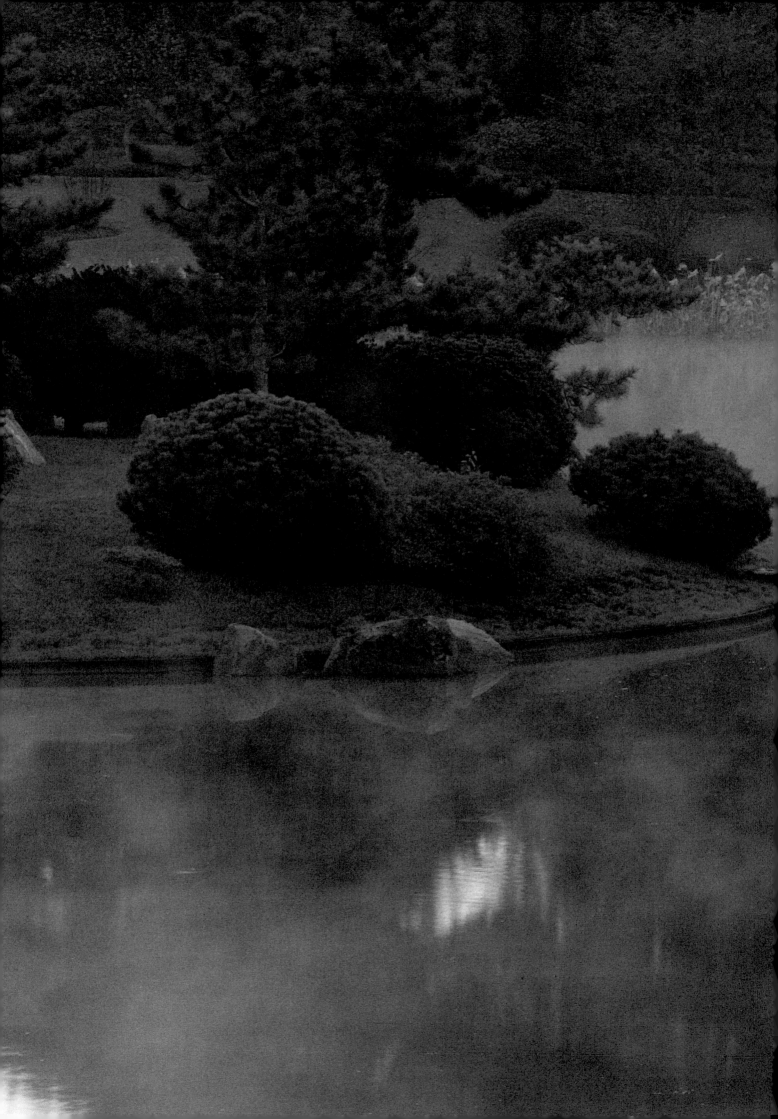

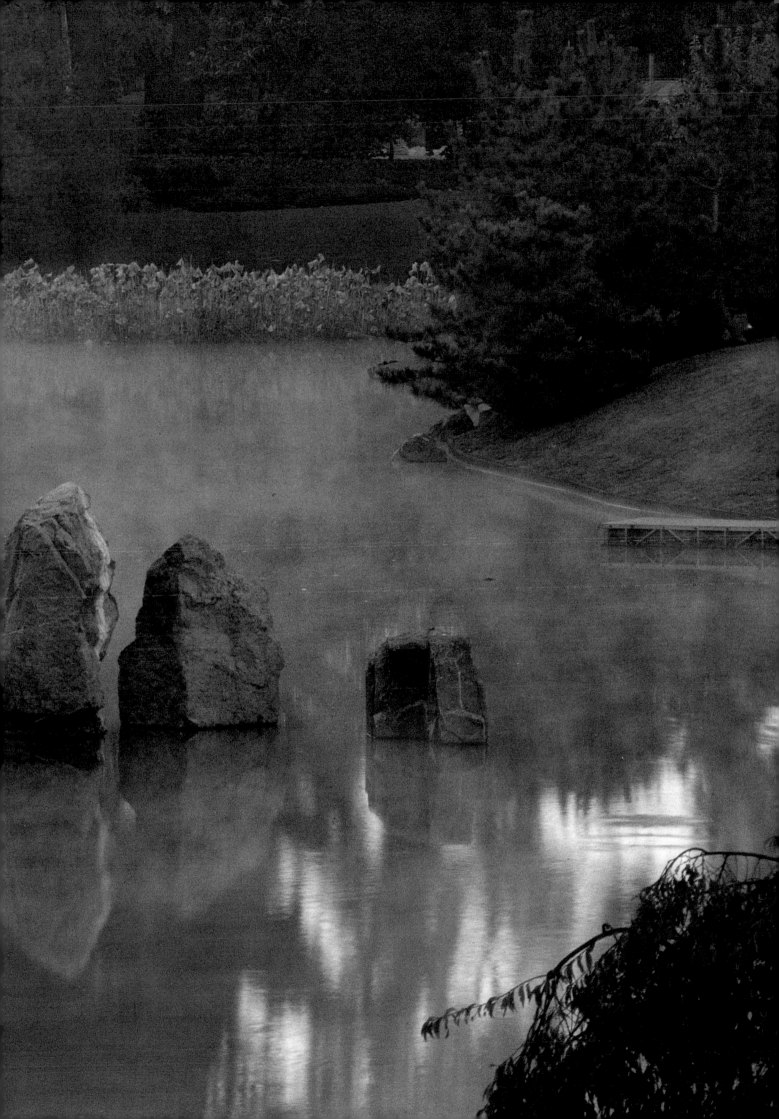

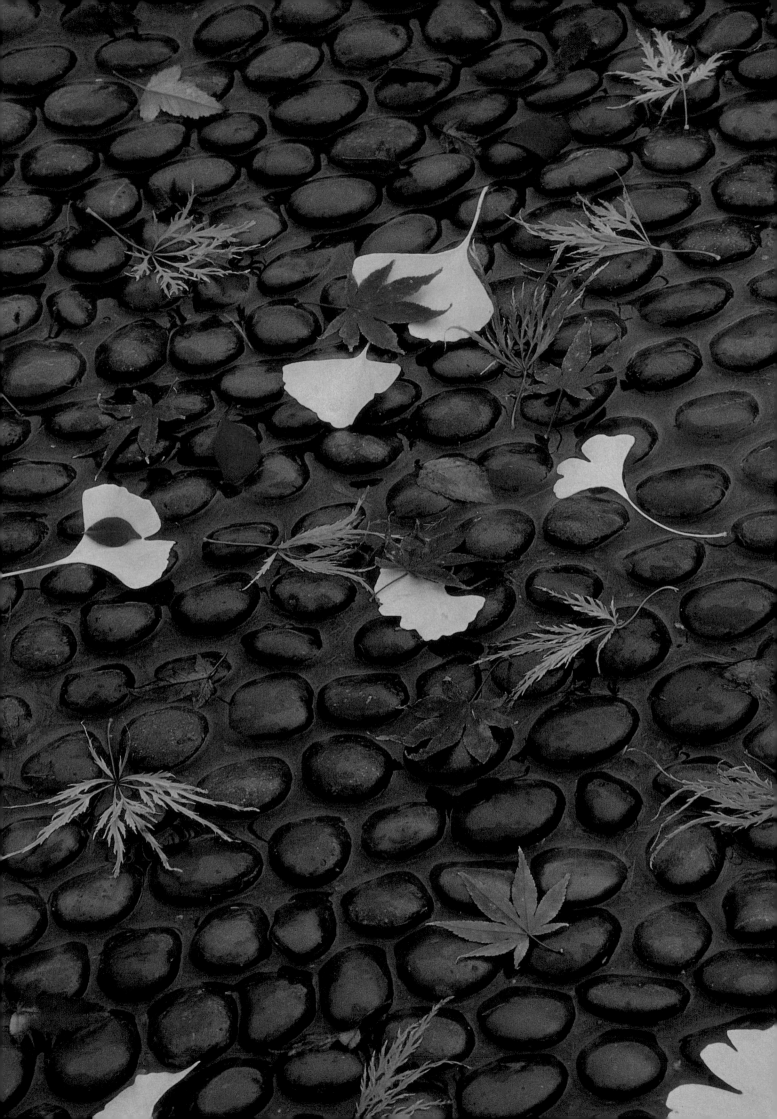

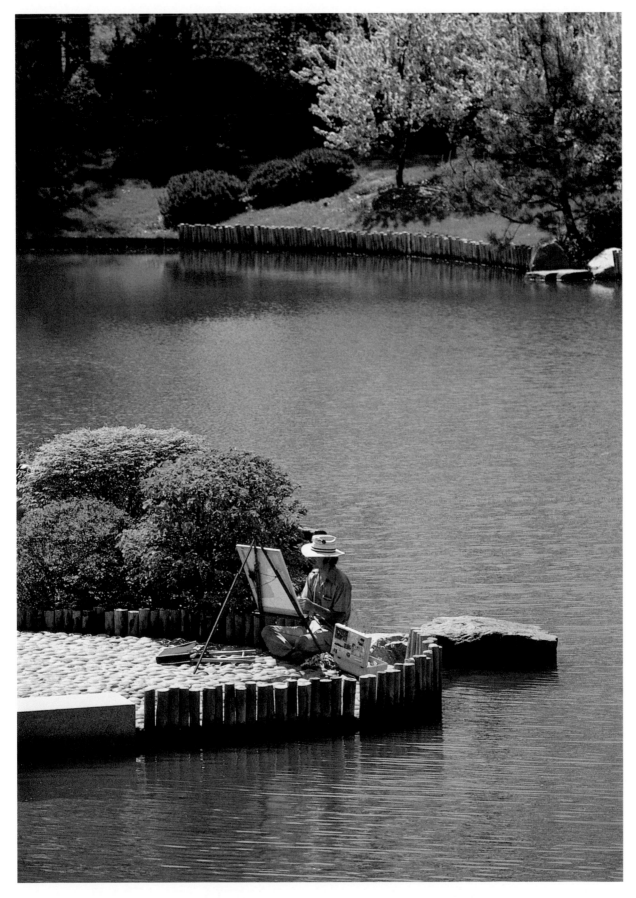

Painter in Japanese Garden at Missouri Botanical Garden. MICKEY MCGREGOR

Japanese maple and gingko leaves at Missouri Botanical Garden. LLOYD GROTJAN

Overleaf: Carp feeding at Missouri Botanical Garden. STANLEY MILLER

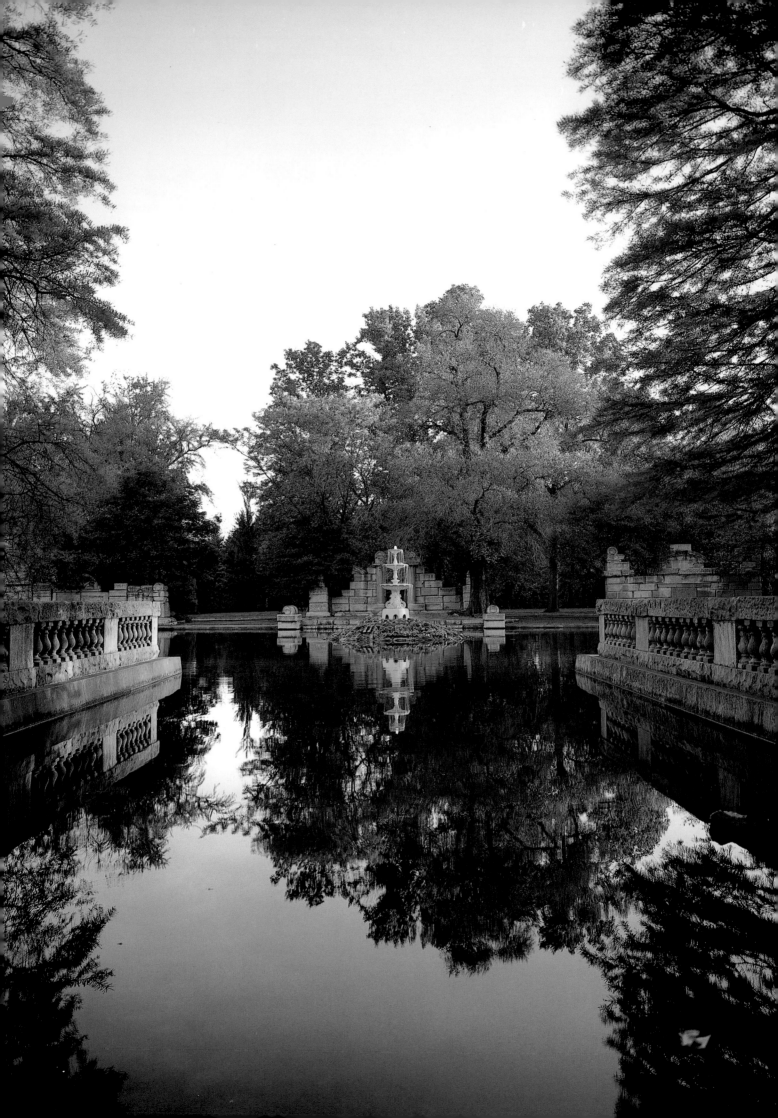

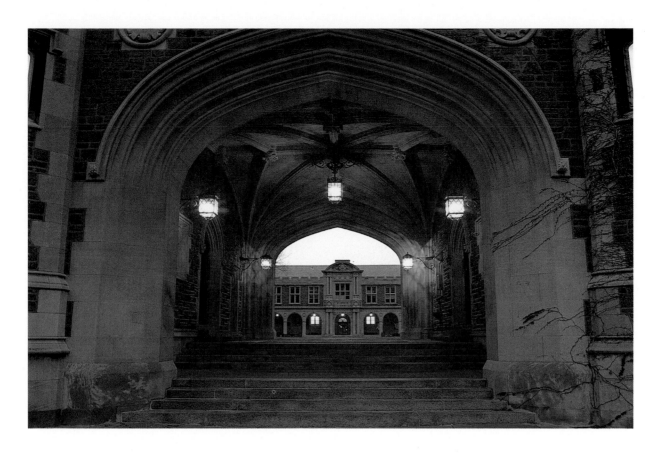

Arch in Brookings Hall, Washington University. GAYLE HARPER

Fountain and ruins at Tower Grove Park. SCOTT SMITH

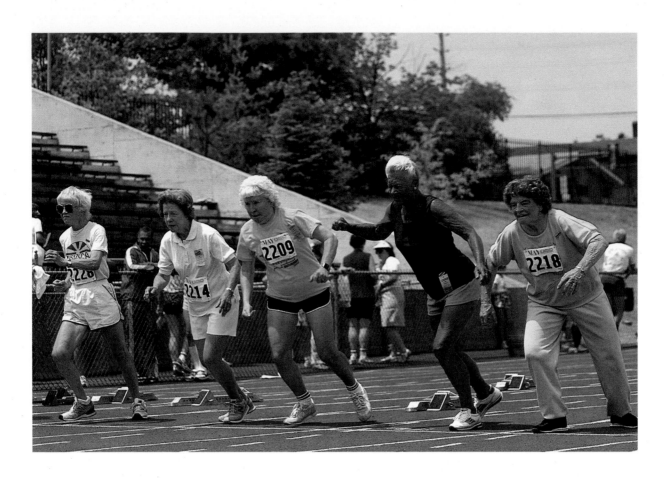

Senior Olympics, Francis Field. PATRICIA DONOVAN

Compton Hill Water Tower, Harvey Ellis, architect. JIM SOKOLIK

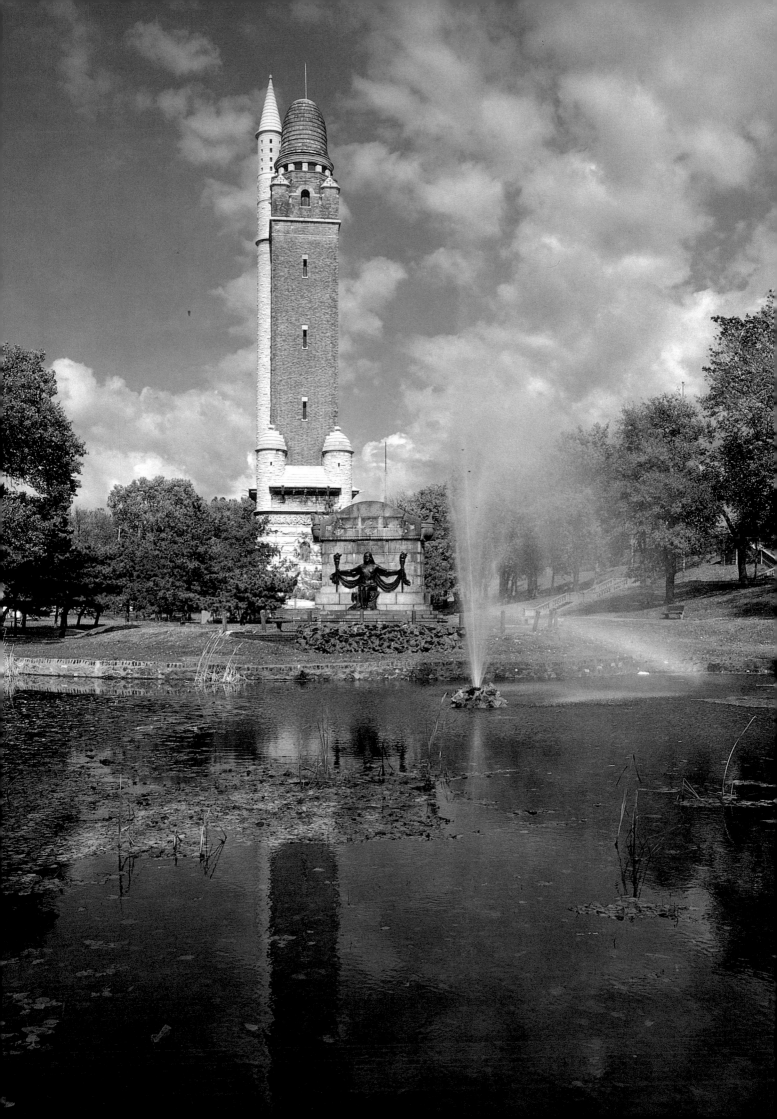

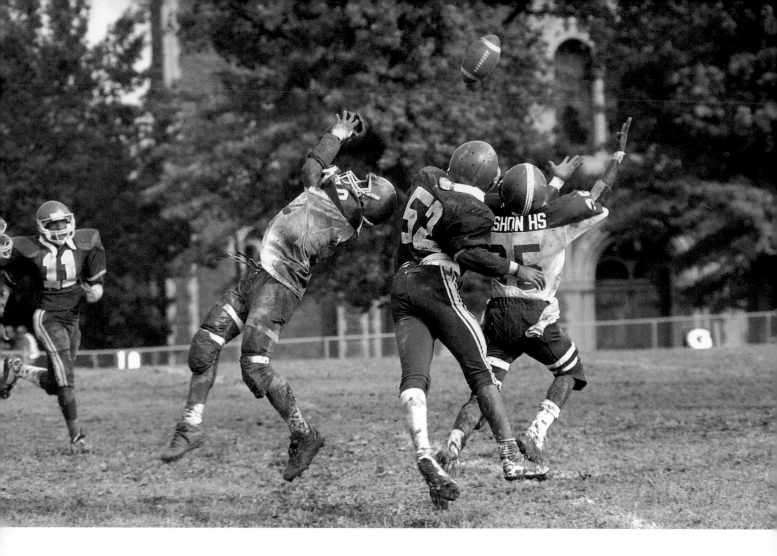

Players from Vashon and Beaumont high schools reach for a pass. BOB WILLIAMS

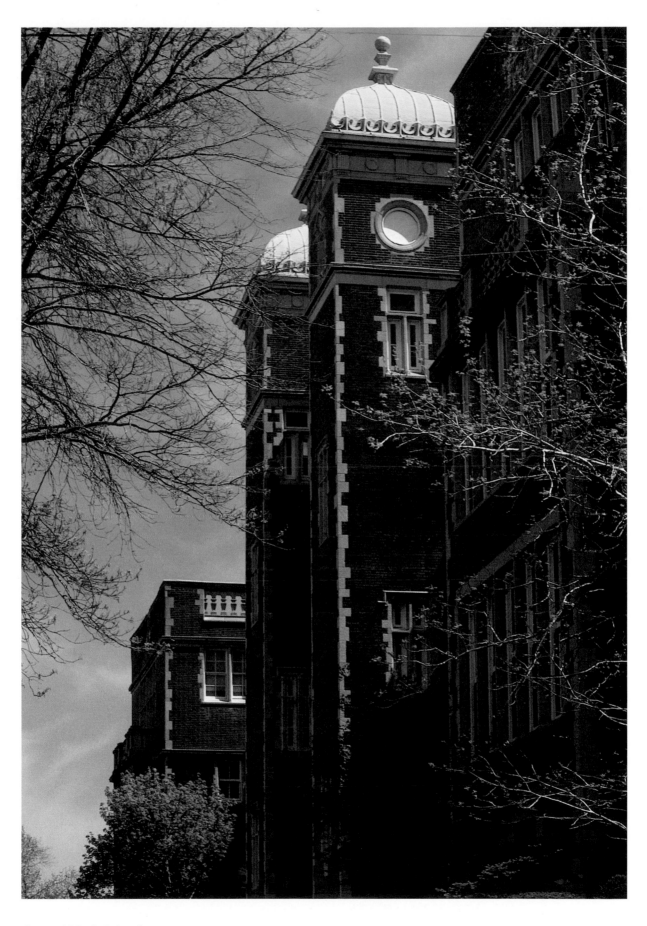

Central High School. GARY TETLEY

83

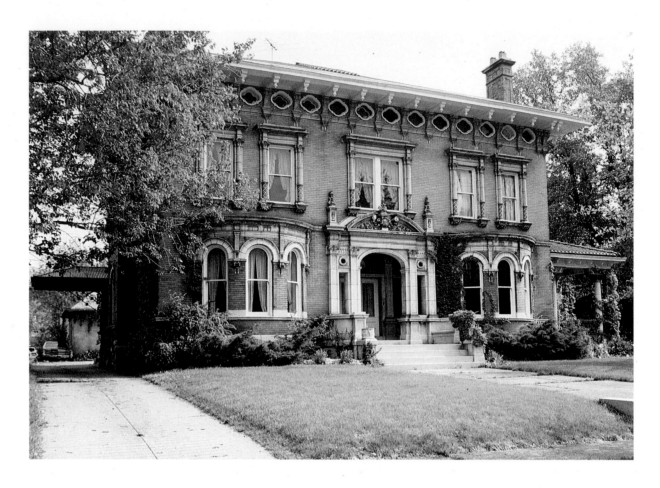

Compton Heights. JANICE BRODERICK

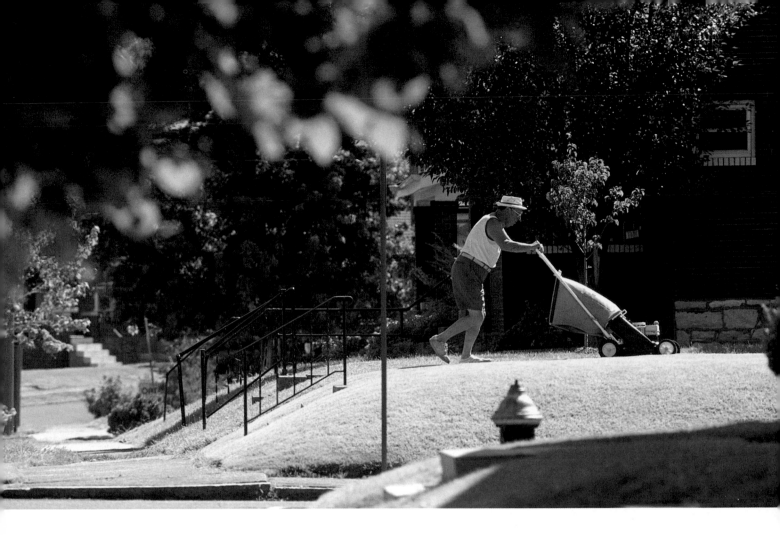

Mowing the lawn in Bevo neighborhood. ROBERT LAROUCHE

Overleaf: Tamale lady at Broadway and Meramec. ELIZABETH CROSBY

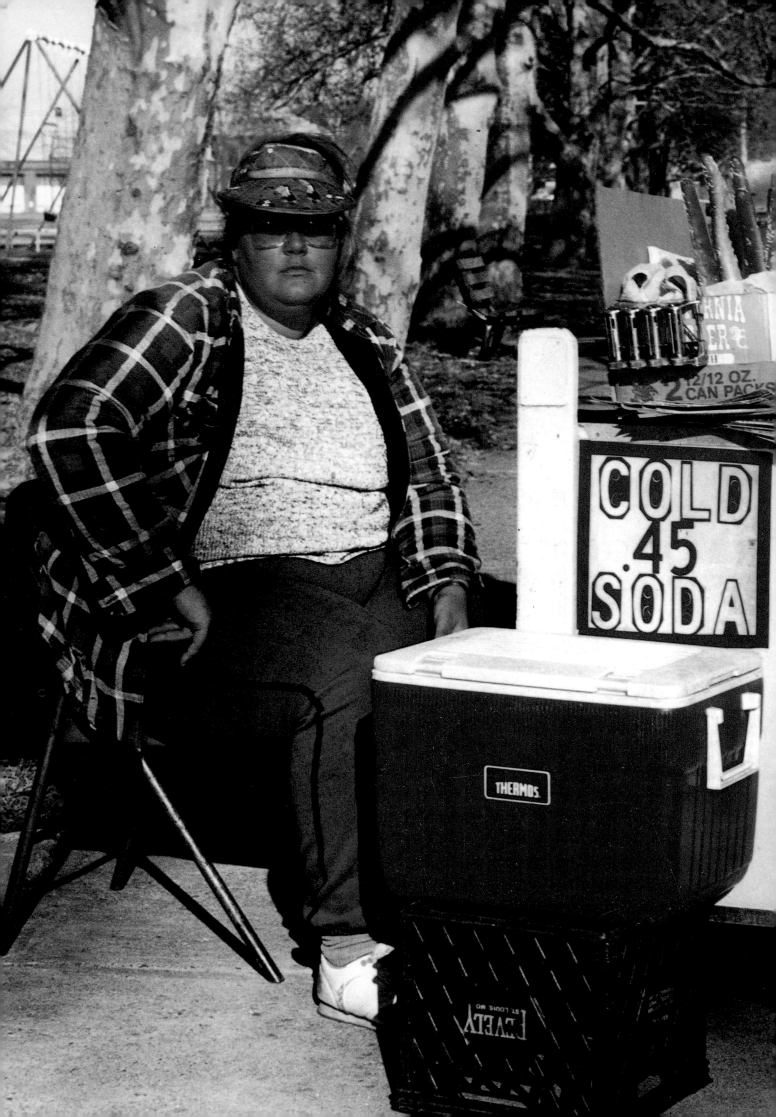

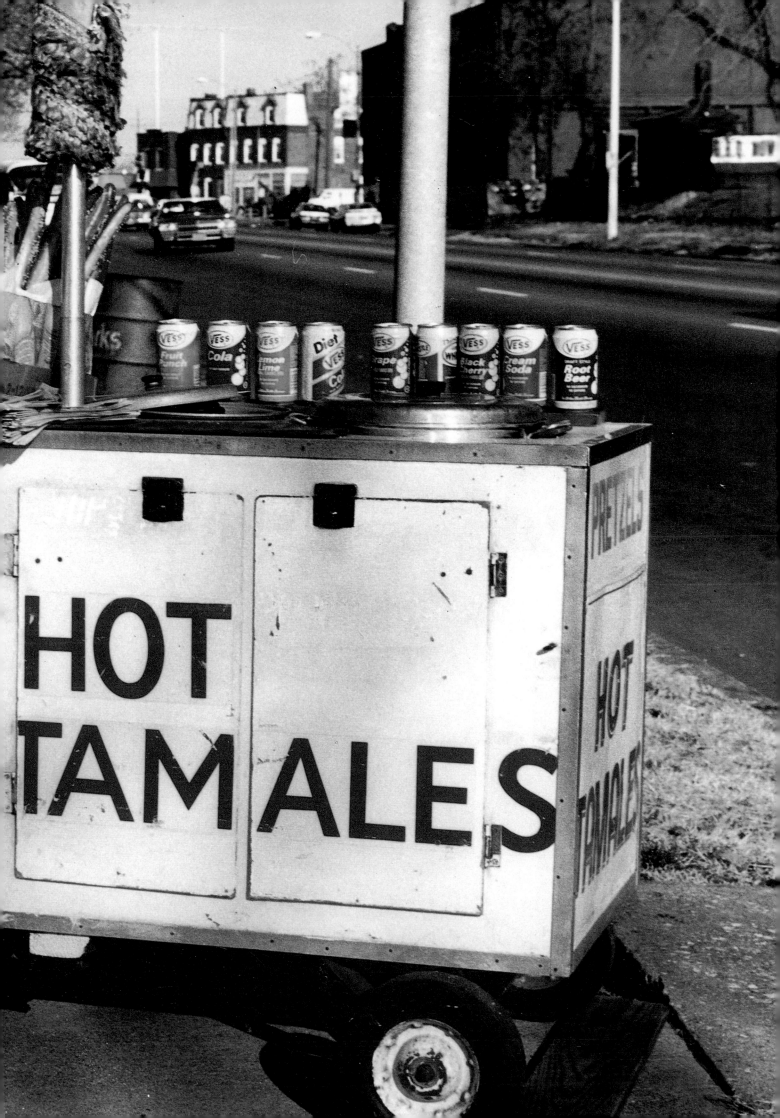

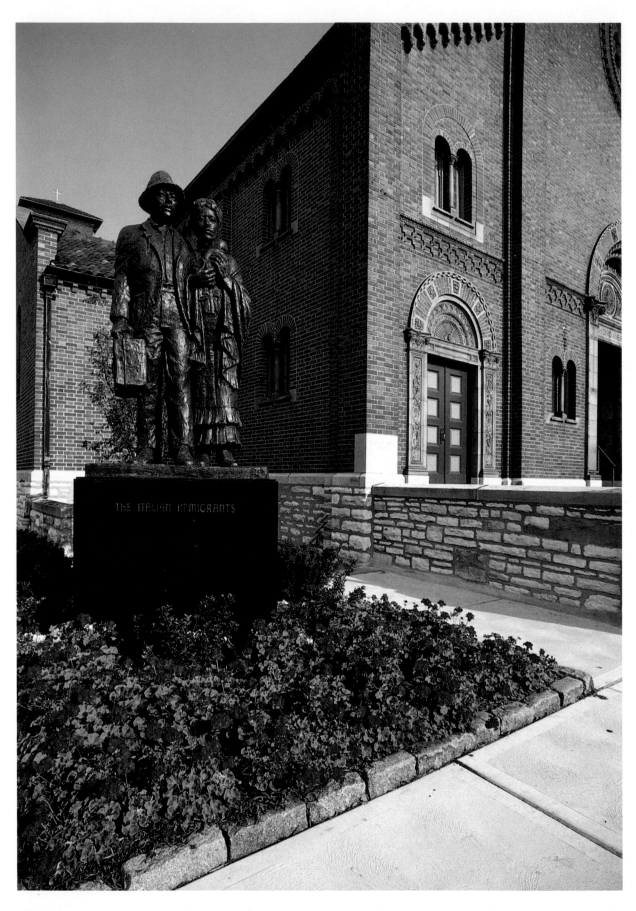

The Italian Immigrants, Rudy Torrini, sculptor, at St. Ambrose Catholic Church on Wilson Avenue.
WILLIAM ENGEL

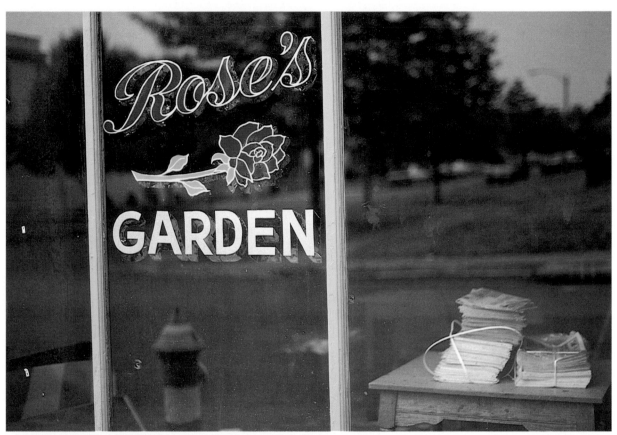

Rose's on the Hill. ROBERT GEORGE

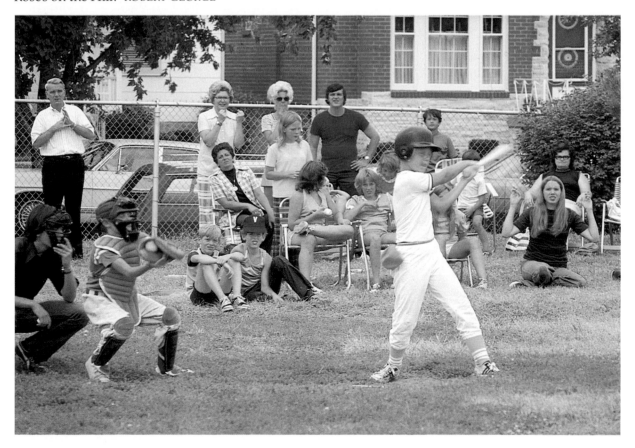

Little league baseball. ROBERT LAROUCHE

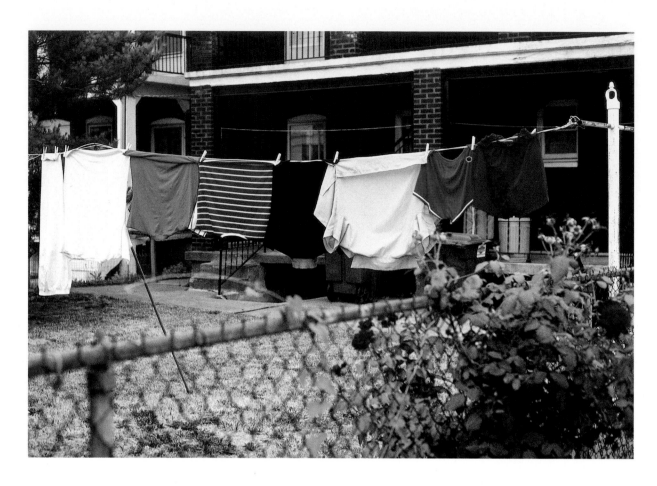

Laundry on the Hill. ROBERT GEORGE

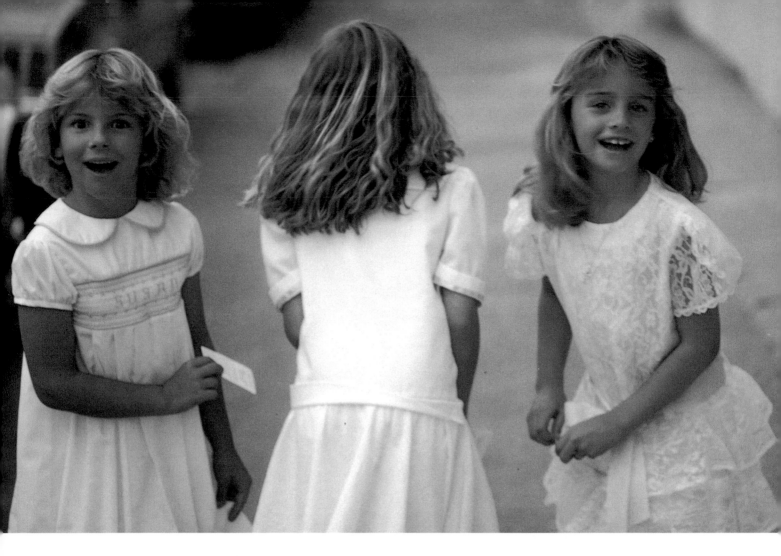

Three girls on Marconi Avenue. ROBERT GEORGE

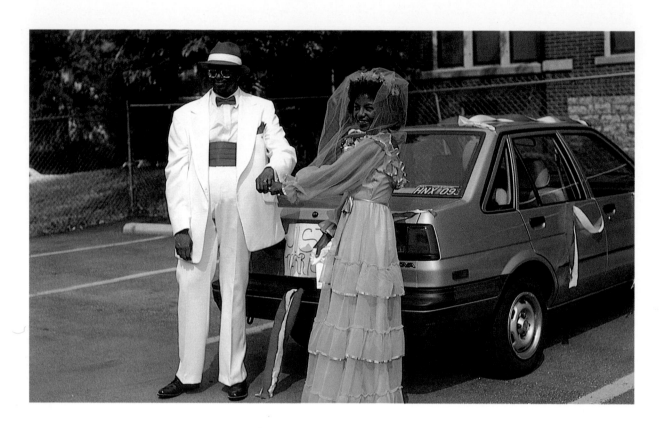

The wedding of Arthur and Pearl Jordan. WALTER FOX

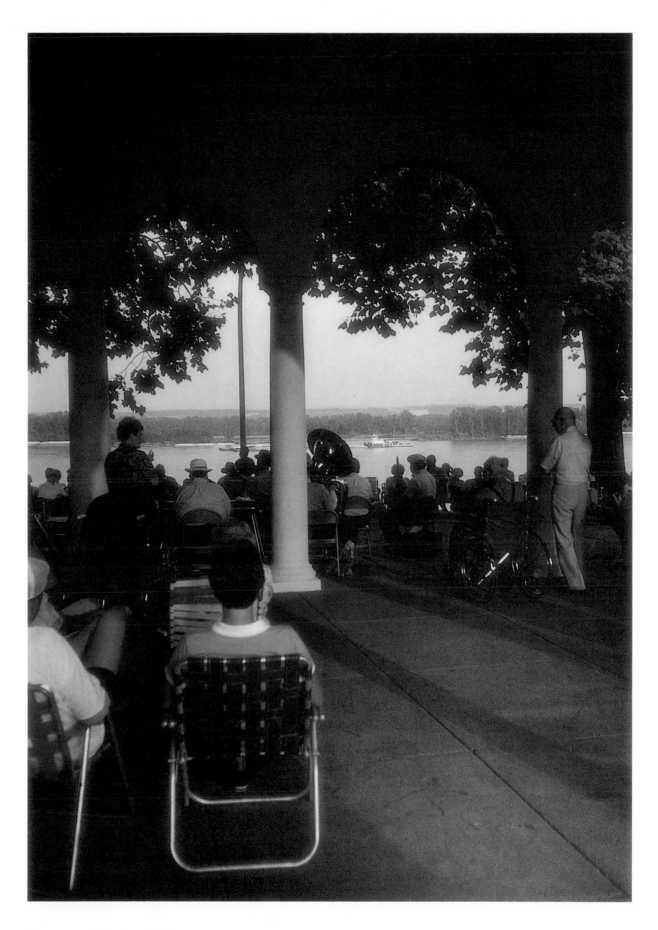

Concert at Bellerive Park. JIM SOKOLIK

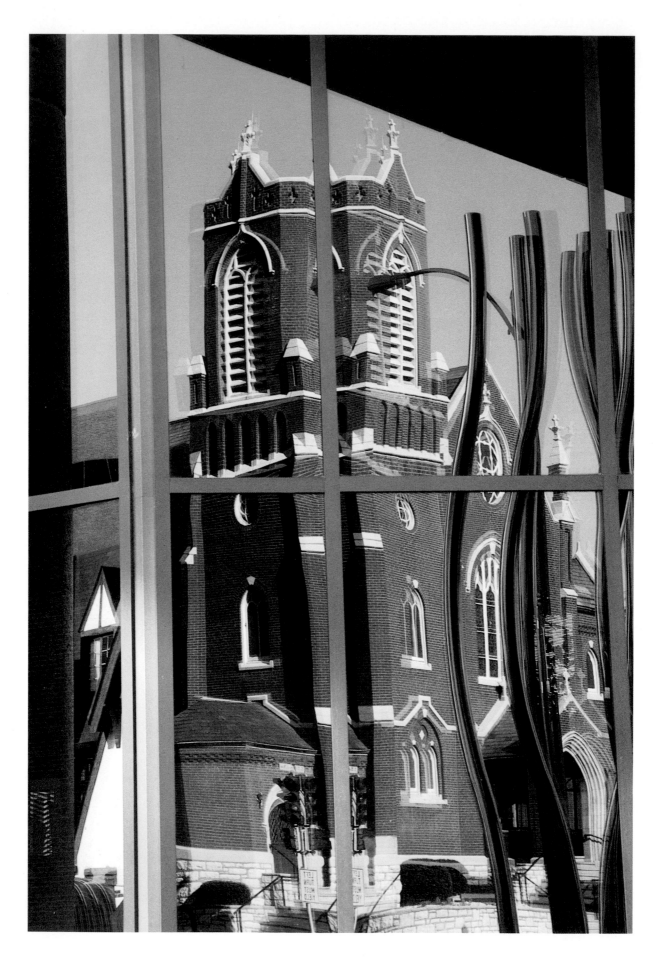

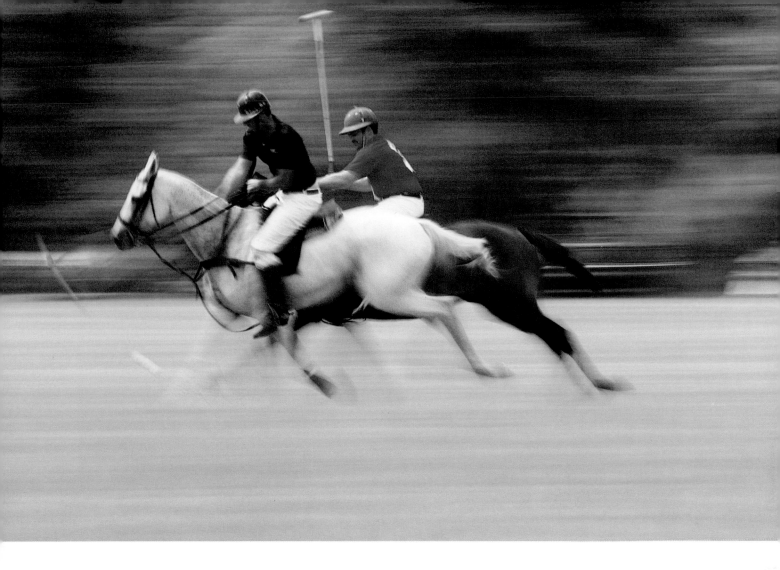

Polo at St. Louis Country Club. LEWIS A. PORTNOY

St. Joseph's Catholic Church in Clayton, reflected in the facade of the Clayton Mercantile Center.
JAMES C. BOBROW

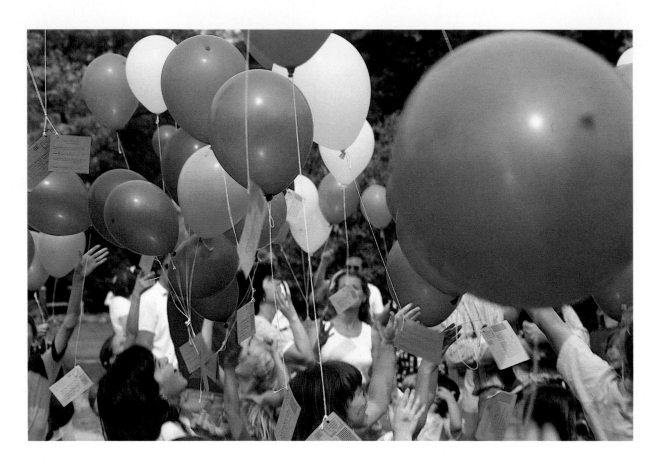

Balloon release, Shaw Park, Clayton. MARSHALL KATZMAN

Pierre Laclede Center, Clayton. MARSHALL KATZMAN

Detail on former bank building in Wellston. GARY TETLEY

Grand staircase, City Hall, University City. CATHY FERRIS

Overleaf: Kirkwood Amtrak Station at Christmas. KATHLEEN M. O'DONNELL

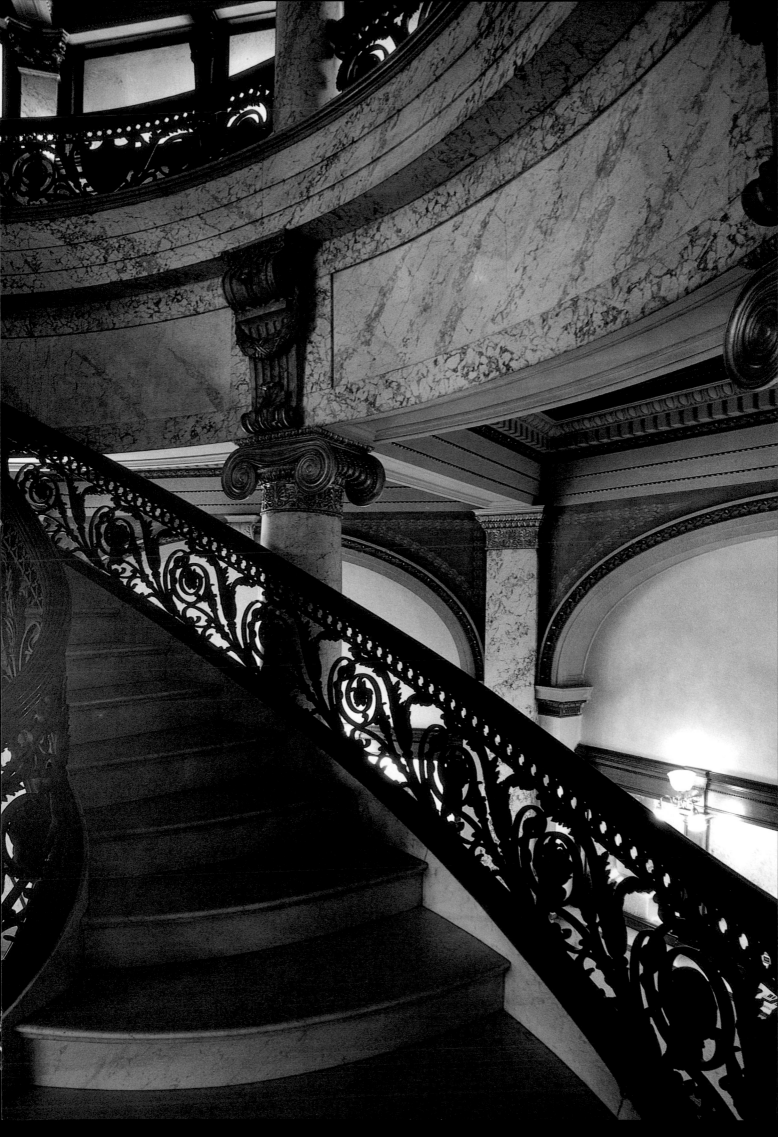

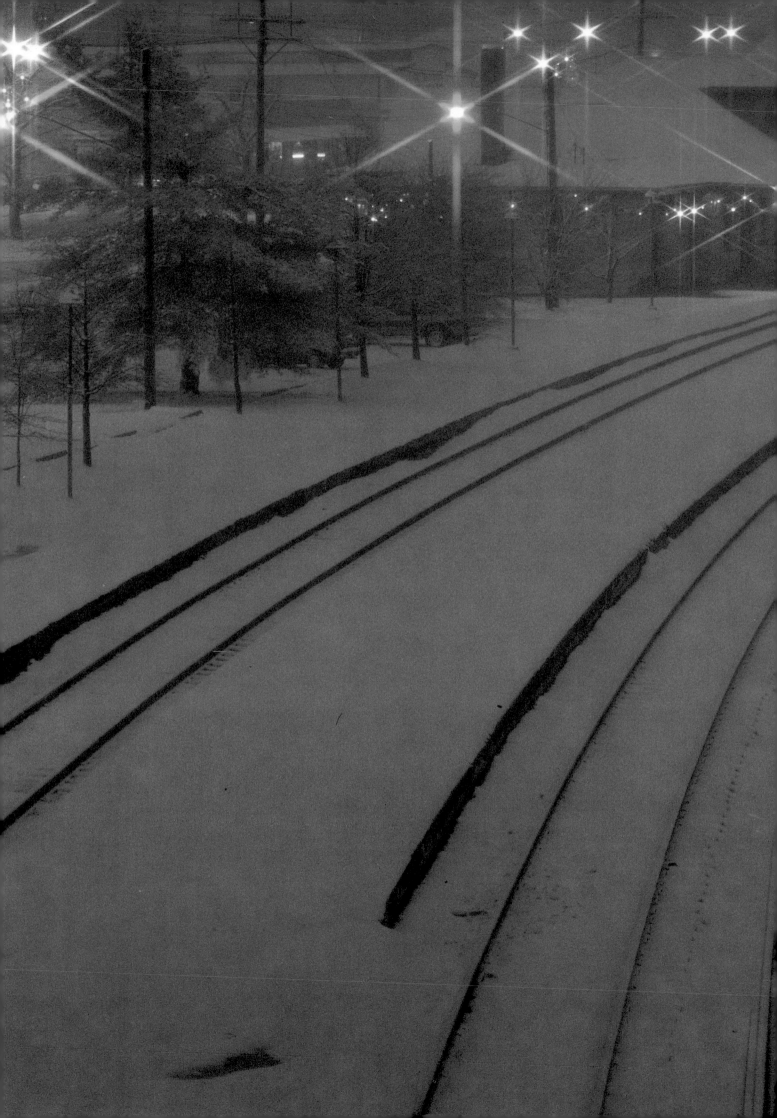

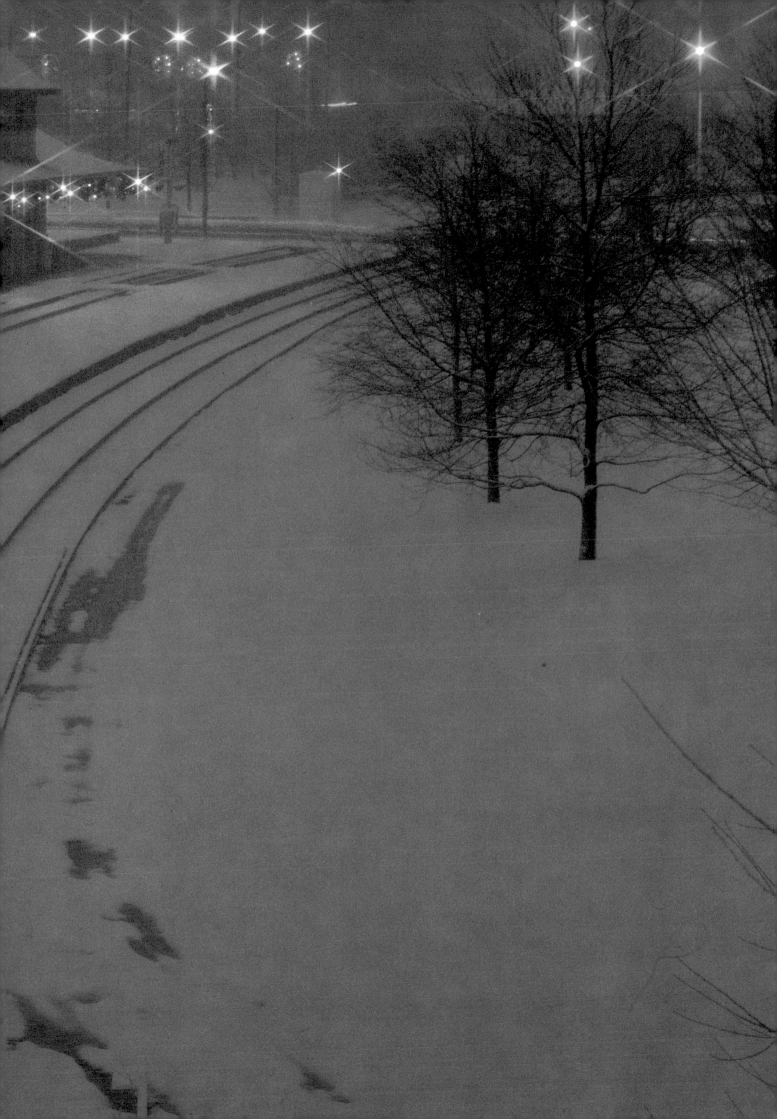

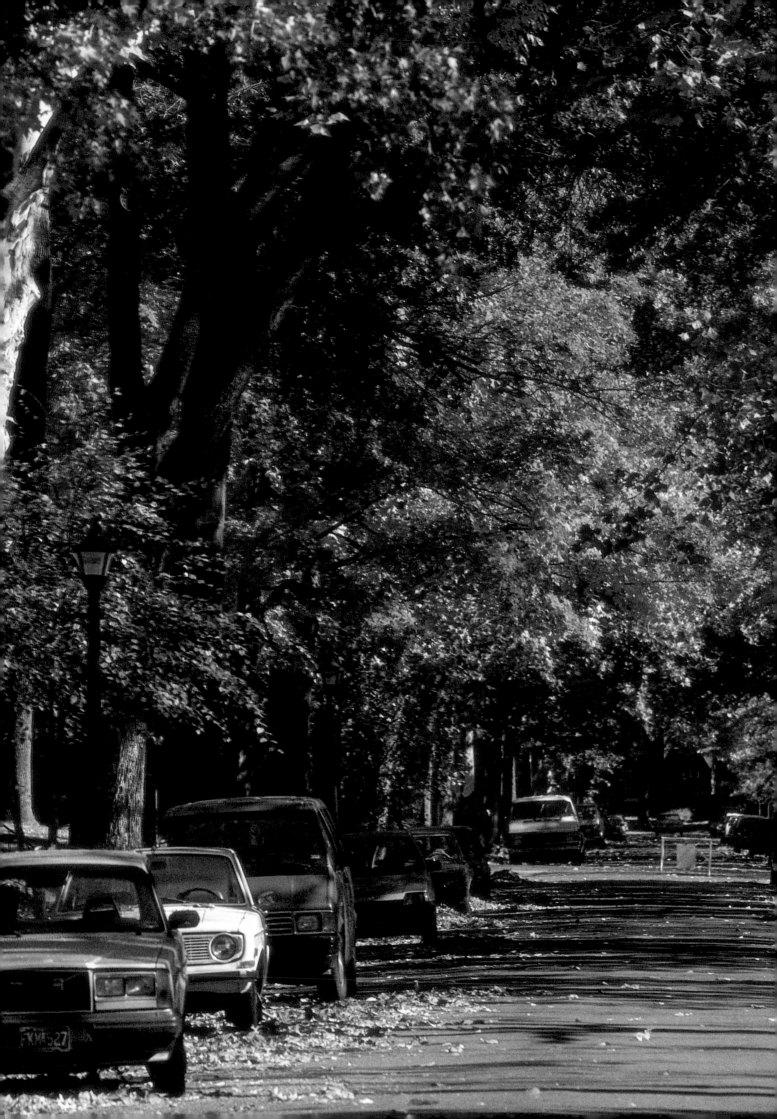

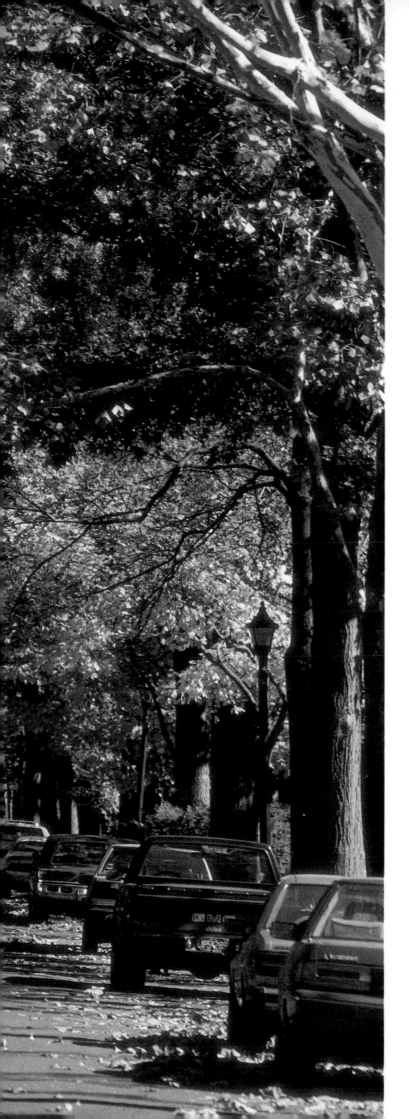

Ames Place, University City. ROBERT GEORGE

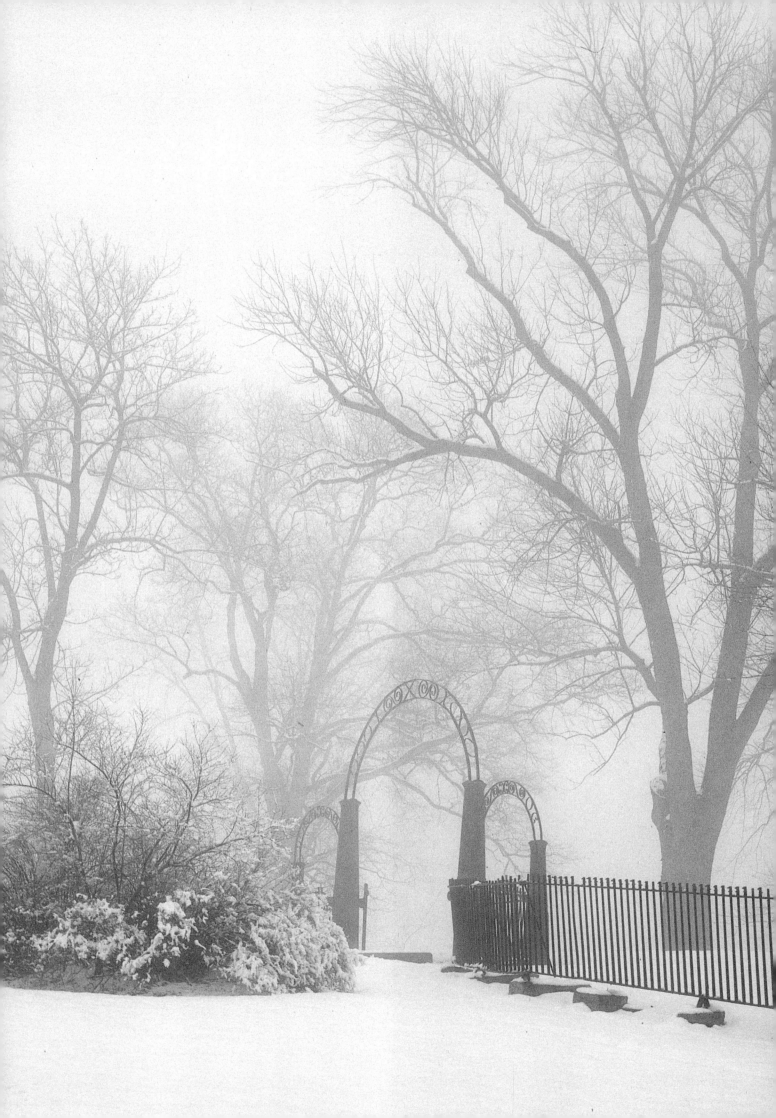

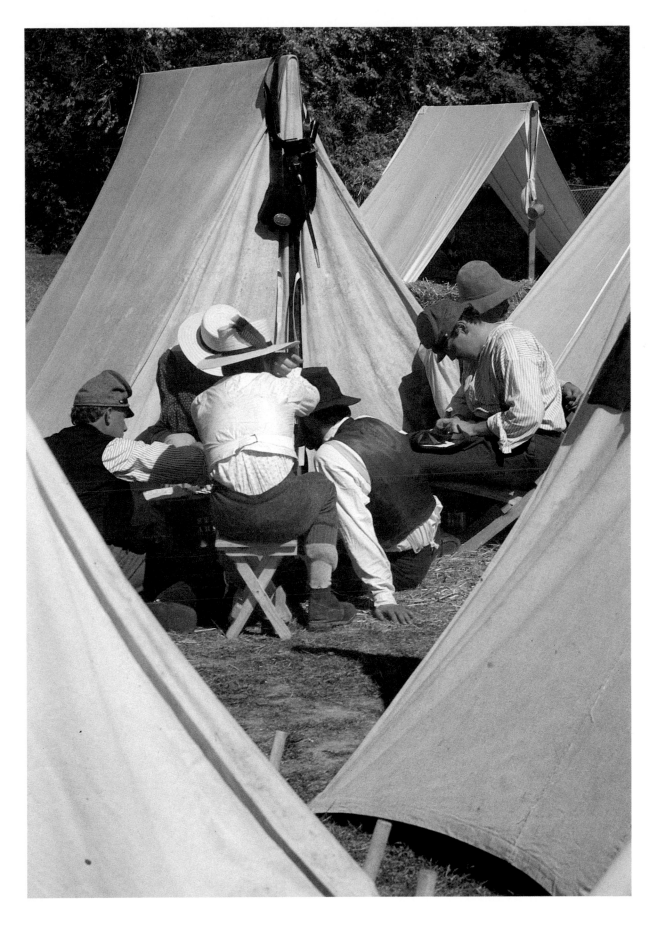

Confederate bivouac at Jefferson Barracks. MILTON G. FEHR

Entrance to river overlook at Jefferson Barracks Historical Park. JON MARX

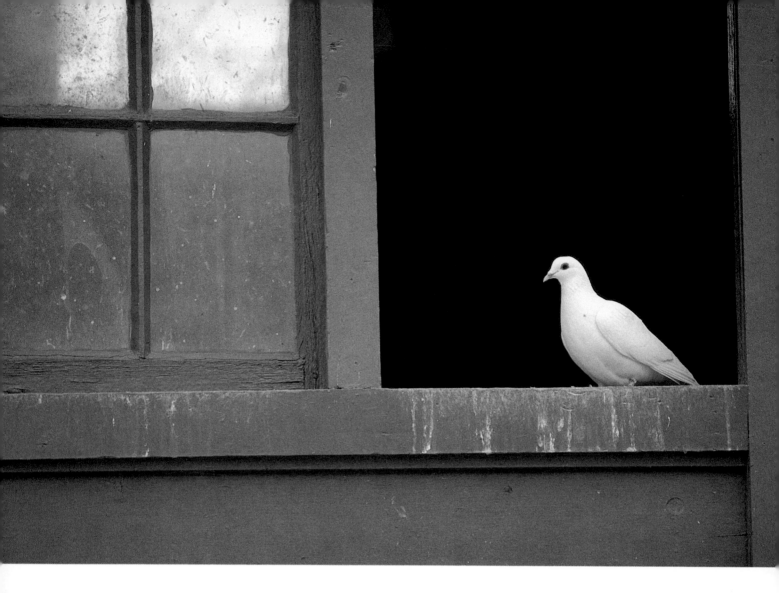

Dove in stable at Grant's Farm. DAVID ULMER

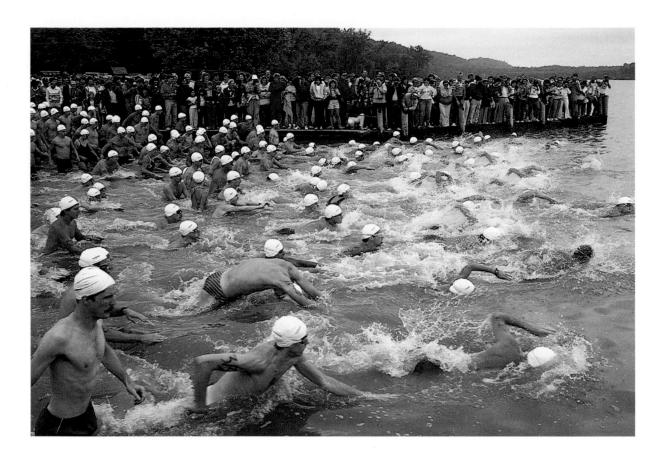

Swim race at Creve Coeur Park. PETER J. GLASS

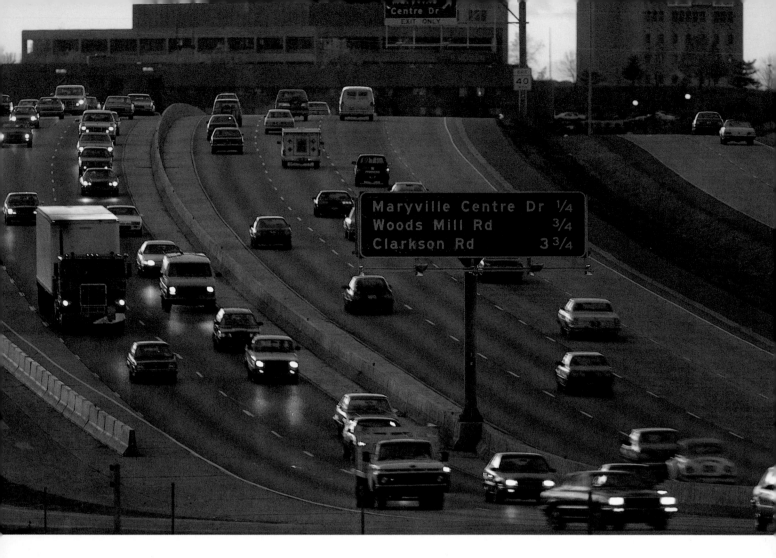

Highway 40 (I–64) at dusk. LEWIS A. PORTNOY

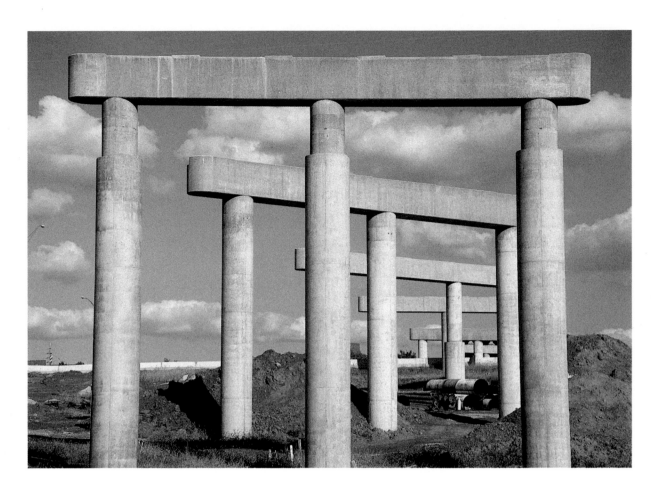

Elevated highway supports at I–270 and Highway 40 (I–64). LINCOLN CROSBY

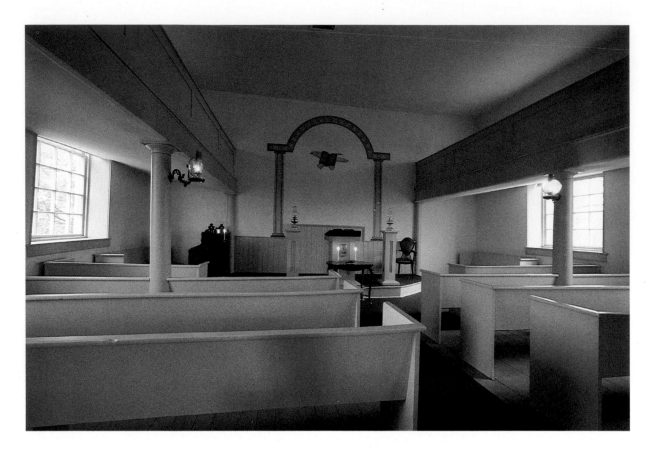

Interior, Old Bonhomme Presbyterian Church. JONATHON WESTLAND

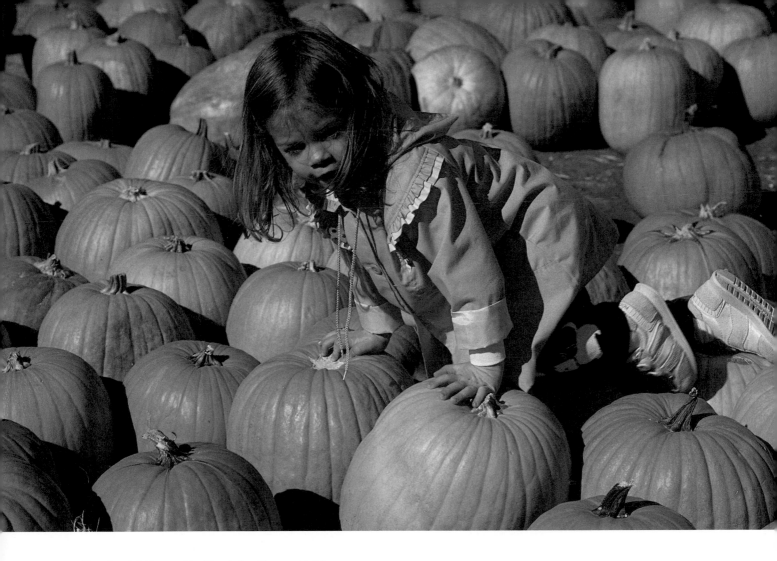

Rombach's Pumpkin Patch in Chesterfield. SHERRY LUBIC

Overleaf: Laumeier Sculpture Park. ROBERT LAROUCHE

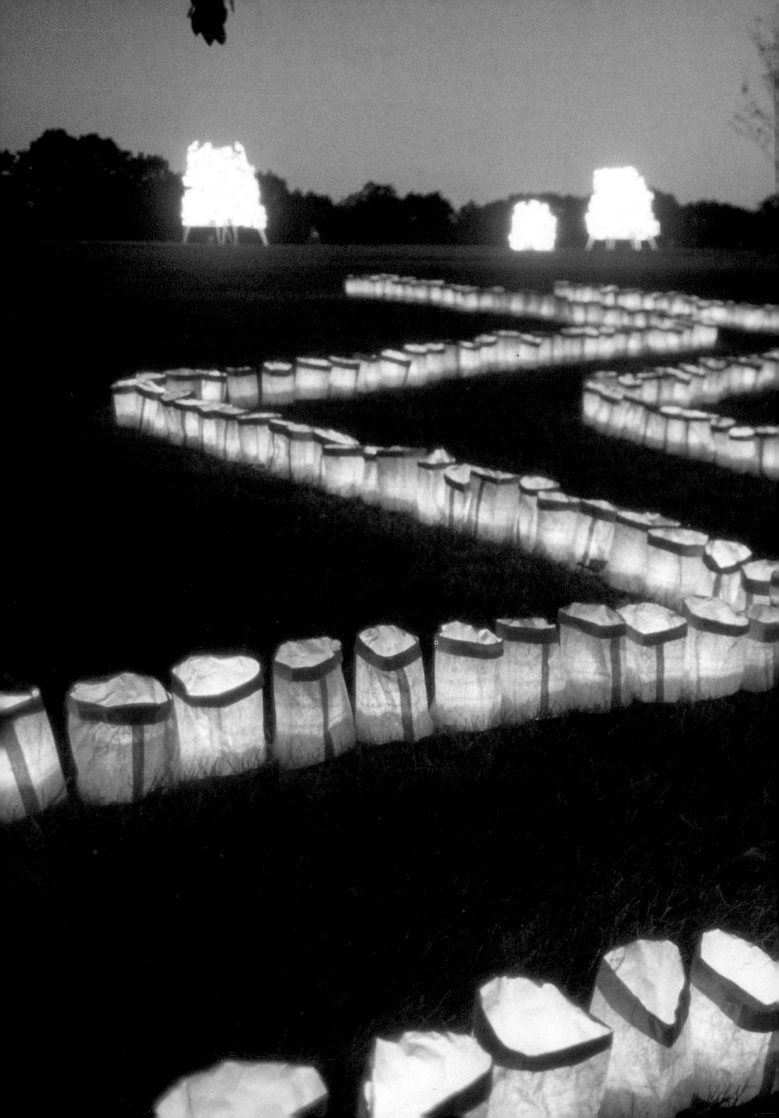

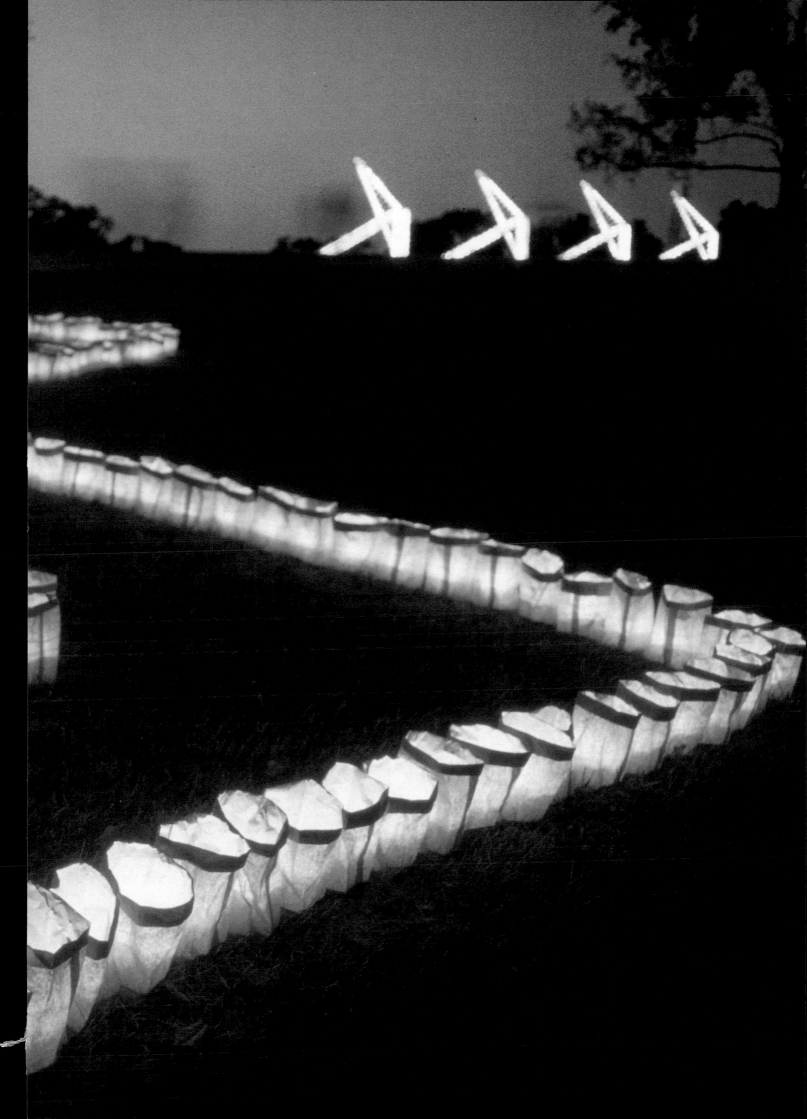

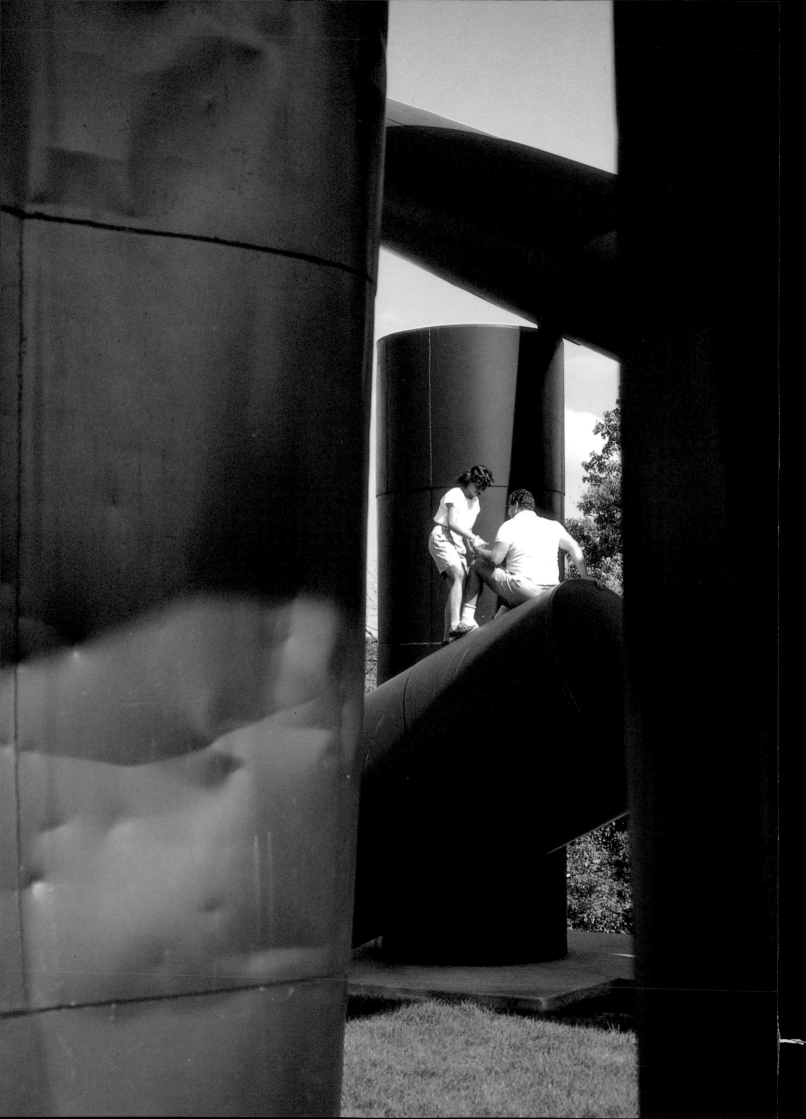

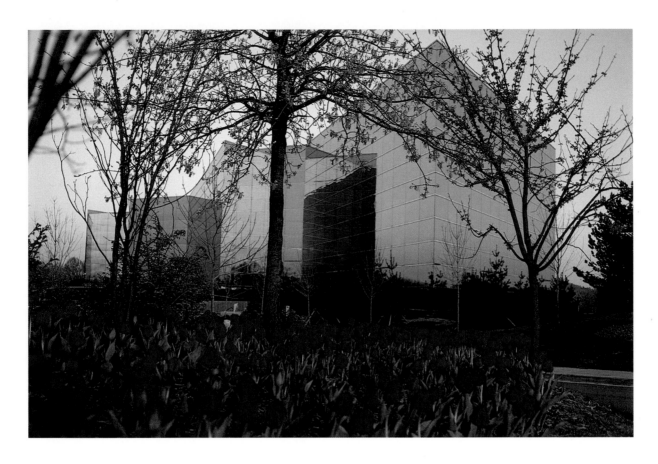

IBM Building, Maryville Centre. LEWIS A. PORTNOY

The Way, Alexander Liberman, sculptor, at Laumeier Sculpture Park. GARRY ROSE

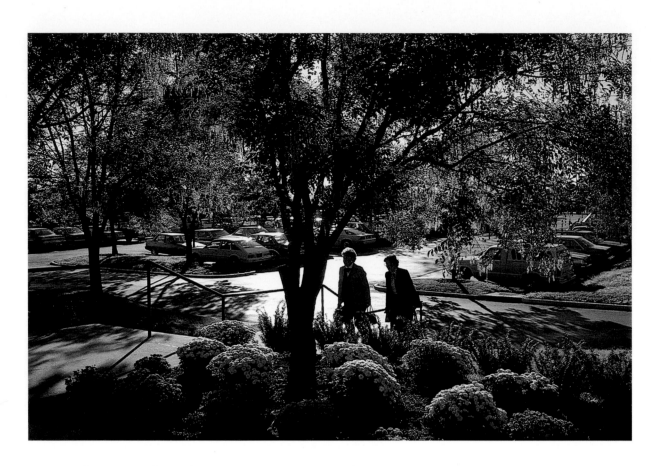

Arriving for work at the Kellwood Building in Chesterfield. SAM FENTRESS

Old St. Ferdinand Shrine, Florissant. GREGORY WOLFF

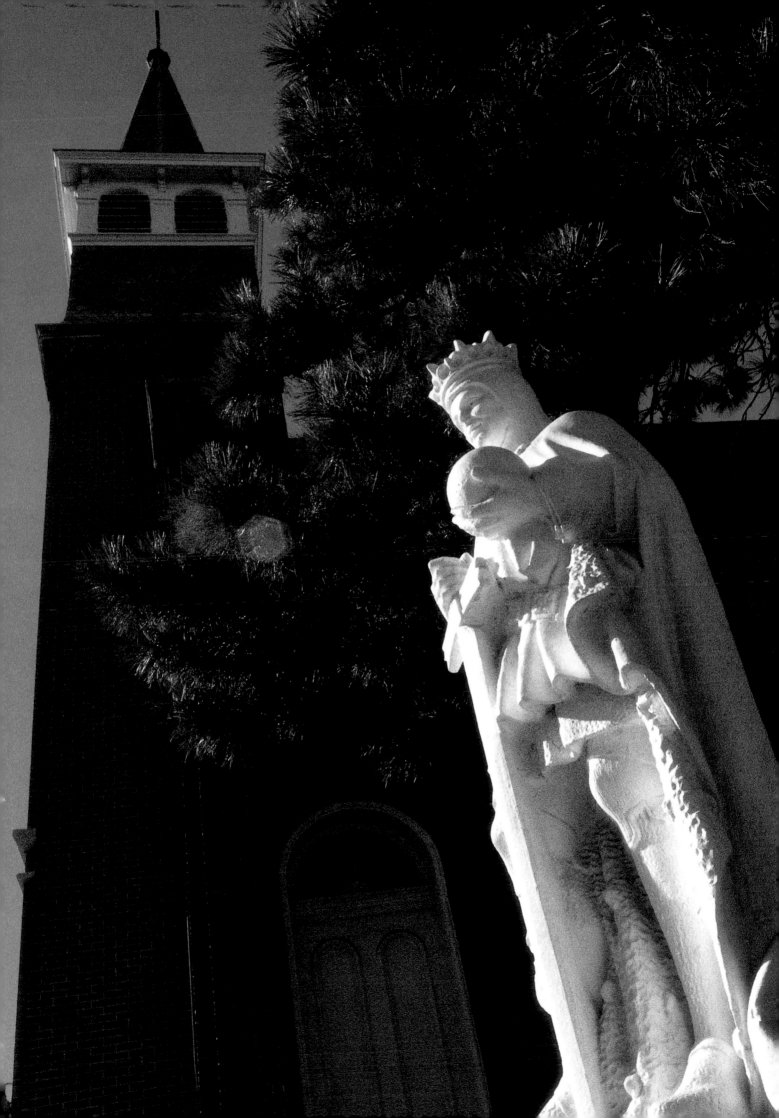

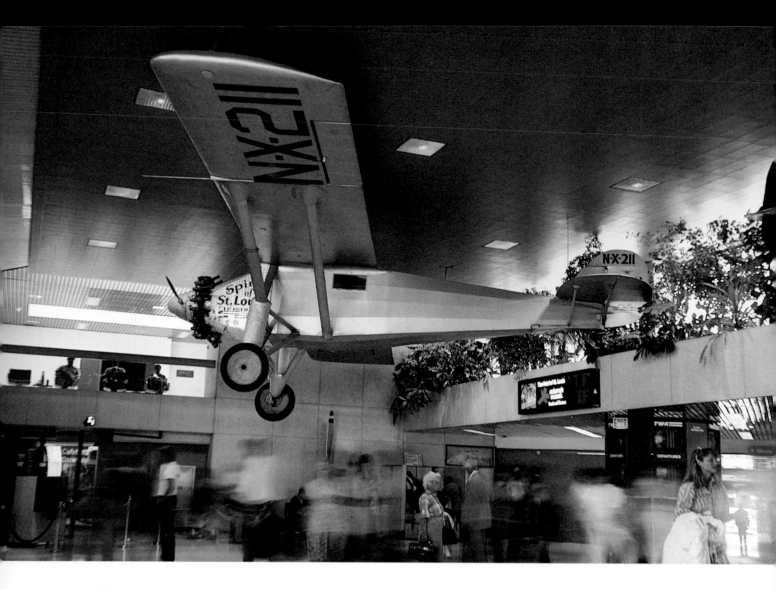

Spirit of St. Louis replica at Lambert International Airport. JEFFREY LAWSON

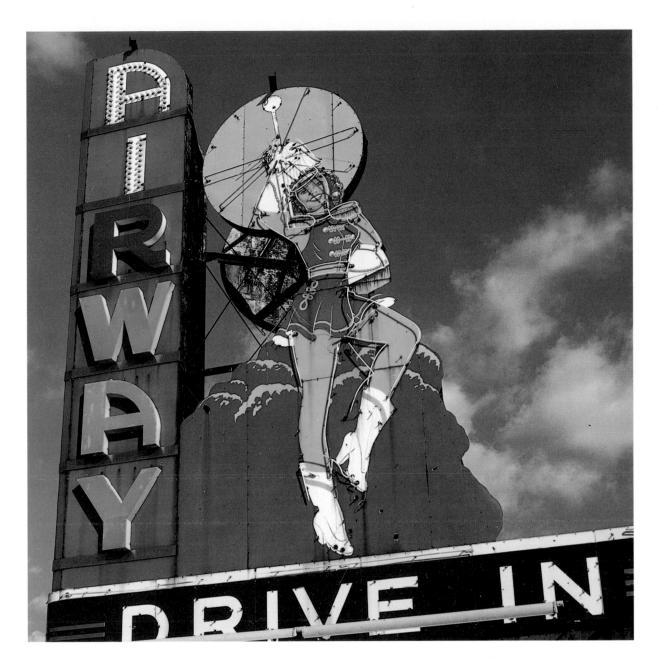

Drive-in on St. Charles Rock Road. QUINTA SCOTT

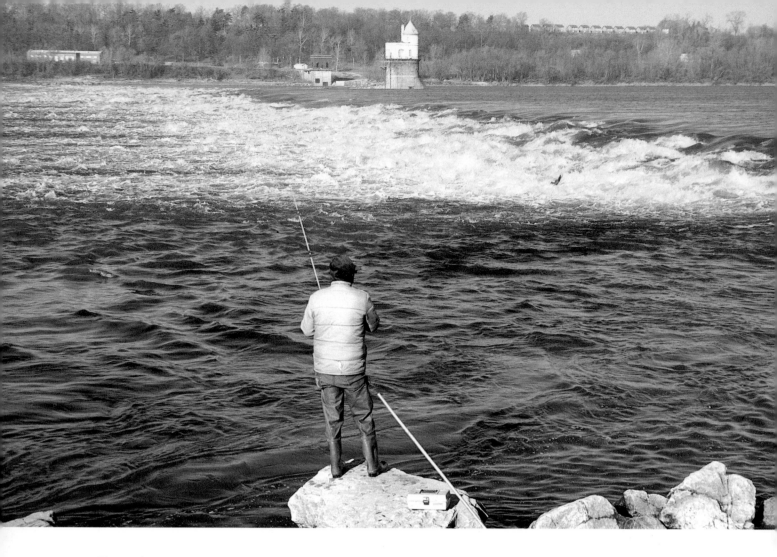

Chain of Rocks. PAUL MARSHALL

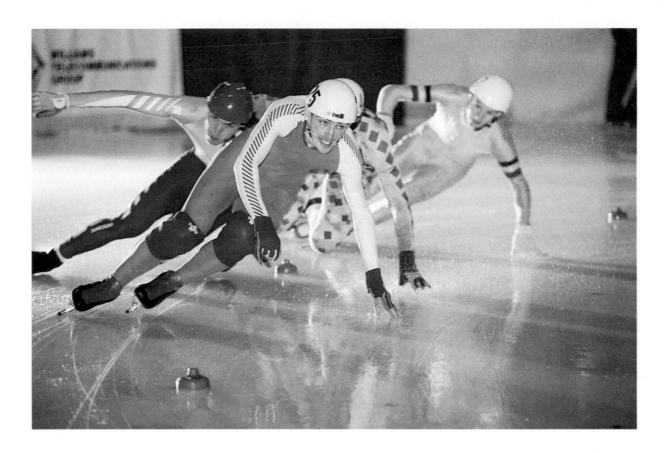

Speed skating championships at Queeny Park. LEWIS A. PORTNOY

Overleaf: McDonnell Douglas Building in Bridgeton. MARSHALL KATZMAN

CONTRIBUTING PHOTOGRAPHERS

James C. Bobrow (p. 94), an assistant professor of clinical ophthalmology at Washington University, has applied his interest in the microcosm of ophthalmic photography toward subjects in the macrocosm. Accompanied by his camera, he has traveled not only throughout Missouri but all over the world, teaching and documenting his impressions. In his photographs, the interrelationships among architectural shapes and surrounding natural forms have created a measure of three-dimensional space as well as a dynamic image on the two-dimensional canvas of film.

Janice Broderick (p. 84), a photographic historian and curator of a corporate art collection, views photography as an important fine art. She teaches photographic history at the university level and is working on an exhibition of the work of a nineteenth-century rural Missouri photographer. Long interested in local vernacular architecture, she developed a photographic survey of the diversity of south St. Louis residential design.

Helen L. Callentine (p. 37), a retired registered nurse, is an enthusiastic amateur photographer. She uses color slides and negatives, which she prints, time permitting. Occasionally she prints black-and-white film using the stabilization method. She is a member of the Photographic Society of America and the Jefferson City Photo Club.

Elizabeth (Betty) Crosby (pp. 62, 86–87) has been an enthusiastic advanced amateur photographer for many years. The retirement of her husband, Lincoln, has allowed time for more extended travel and serious photography in distant parts of the world. Since they completed a comprehensive photographic documentation of Missouri, their team endeavor has concentrated on the national parks of this country.

Lincoln Crosby (pp. 67, 109) began his serious interest in photography with twenty-five years of moviemaking. His movies document both domestic and international travel, with extensive coverage of remote areas and isolated peoples. Seven years ago, his retirement and his shift to 35mm format expanded his photographic effort. His wide-ranging travel continues, and he is especially concerned with the balance between our world's natural grandeur and patterns of life in the cultures around us.

James A. Cuidon (p. 6) became strongly interested in photography after his wife gave him a Canon AE–1P for his birthday in 1984. That began a rapidly increasing desire to record beauty on film. His primary subjects, aside from his family, are downtown St. Louis, the Missouri Botanical Garden and Arboretum, and the general countryside. His recent prize-winning slide essay about the Missouri Botanical Garden, titled "An Unseen Garden," has been presented at St. Louis County libraries. Perfect "natural light" pictures are Jim's primary objectives in photography.

Patricia Currie (p. 23) is looking forward to a career as a free-lance artist and photographer. Her work has been exhibited in several St. Louis art galleries and business establishments. She received an honorary mention from the Photography USA 1988 competition in Pennsylvania for one of her Cardinal baseball rally photographs.

John Dignan (pp. 15, 16–17), production director for a creative department at Maritz Motivation Company, began his photographic career six years ago after his wife promised to buy him a camera if he quit smoking. He has since traded one addiction for another, spending his free time either taking pictures or processing and printing them in his own color darkroom. This past year he has begun free-lancing professionally to support his photographic habit.

Patricia Donovan (p. 80) became intrigued with photography three years ago when she bought her first camera. After taking a Photo I class, she joined the St. Louis Camera Club. She has received numerous awards, including rookie-of-the-year and monetary awards. Her photographs have been published in a local magazine and in newspapers. Pat's goal is to become a professional photographer.

Bill Engel (p. 88) has been an avid photographer for much of his life. His photographic subjects have ranged from advertising and editorial assignments to travel, nature, and dance, and his work has appeared in many national publications. Bill's favorite subjects are landscape and nature photography, and his wall decor prints are displayed in a number of major St. Louis industrial and commercial facilities.

Milton G. Fehr (p. 105) is a graduate of the College of Graphic Arts and Photography at the Rochester Institute of Technology. He has pursued a career in the printing and book production field. His free-lance work has appeared in various publications, including *Popular Photography*. He is a member of the St. Louis Camera Club and is a star exhibitor and member of the Photographic Society of America.

Sam Fentress (p. 116) has been a St. Louis photographer since 1981. His commercial photographs of architecture and interiors have been published in numerous trade magazines. His artistic work, photographs of vernacular iconography in over twenty states, is included in the collection of the Art Institute of Chicago and has been widely exhibited.

Cathy Ferris (pp. 68, 99) began photography as a hobby, but has gone on to shoot a wide range of editorial and commercial assignments. Her extensive stock file of images includes people, nature, landscapes, photomicrographs, and of course St. Louis.

Walter Fox (p. 92), who lives in St. Louis, has taken photographic courses on an intermittent basis for about fifteen years, including course work during the last six years at St. Louis Community College at Forest Park. He entered pictures in the Best of College Photographers annual competition in 1984 and 1986.

Robert George (pp. 2, 18, 89, 90, 91, 102–3) has traveled widely in the United States and Europe as a travel and fine-art photographer. His work has appeared in literary journals, magazines, and brochures. He is currently doing black-and-white portraits and working on an exhibition titled "Poems of Paris." He lives with his family in University City.

Peter J. Glass (pp. 64–65, 107), a University of Missouri–St. Louis graduate and a resident of Florissant, photographs nature, landscapes, and a variety of subjects around St. Louis and throughout Missouri. He works both with color slides and in black and white. He credits his affiliation with the St. Louis Camera Club as a source of learning and motivation. His work also appeared in *Colorful Missouri*.

Lloyd Grotjan (p. 74) has been involved in photography from an early age. Grotjan owns Full Spectrum Photo, a commercial photography firm in Jefferson City. His work has been published in numerous magazines and periodicals and is on permanent display throughout the state.

Rose Ann Haeuser (p. 63) takes her 35mm camera everywhere, looking for that special shot. After quitting her secretarial job, she is now a homemaker living in Jefferson County. She is always looking for photo competitions and has won awards and publication for some of her work. The latest was an award in the 1988 Cuivre River State Park nature photo contest and publication in the 1987–1988 *Official Manual of the State of Missouri*.

Gayle Harper (p. 79), the executive director of Girls Clubs of Springfield, Missouri, purchased her camera in August 1987. An active member of the Southwest Missouri Camera Club, she devotes as much time as she can to the art form that provides ever-increasing fulfillment and excitement. Also an avid traveler and explorer, she enjoys working to capture the flavor of a place and of the people who live there.

David Hinkson (pp. 18–19, 32) has pursued photography as a hobby and part-time business since picking up his first 35mm camera while serving with the U.S. Marine Corps in South Vietnam. His photographs have been printed by several magazines, newspapers, and wire services. For the past five years, he has been responsible for coordinating the efforts of more than twenty photographers covering the VP Fair in St. Louis.

Dan Johnson (p. 8) is an active member of the St. Louis Camera Club and currently serves as the club's color slide chairman. He has judged at area camera club competitions, has given programs at libraries, and has taken photographs for historical societies in Missouri, Illinois, and Indiana. He is one of the presenters for the St. Louis County Parks photography seminars. His subject matter is varied but often focuses on the lighter side of life.

Carol Kane (pp. 72–73) bought her first camera in 1986, as the result of a desire to take on a serious hobby. Having raised five children, she found it easy to apply the intensity of a homemaker to her photography. She reads everything she can lay her hands on and then goes out and shoots her own way. To Carol, composition is the prime consideration when making a photograph. Her favorite subject is the Missouri Botanical Garden and Arboretum.

Marshall Katzman (pp. 35, 96, 97, 122–23), a native St. Louisan, received his M.D. degree in 1962 but continued to exhibit his oil paintings and welded sculpture. Photography became his major form of expression after his first one-man show in 1979. Using the camera to create his art, he extracted the colors, patterns, and textures of man-made objects in the urban environment. His work has been published in newspapers and magazines, he has had twelve one-man shows (including ones in France and Mexico), and he has been represented by galleries in New York, Washington, and Los Angeles.

Robert LaRouche (pp. 1, 51, 52, 57, 69, 85, 89, 112–13) has been a journalist since his first assignment as editor of a grade school newspaper in New Jersey. For the past thirty years he has been a staff photographer for the *St. Louis Post-Dispatch*, recording all aspects of his adopted home town. A teacher and writer as well as a photographer, he brings a personal aesthetic to the job of telling a story with pictures.

Jeff Lawson (pp. 24, 118) has been a photojournalist for nearly thirty years. Some of his most significant early work documented the civil rights movement and Vietnam. His photographs have been used by AP, UPI, CBS, *Ebony*, and *Glamour* and have appeared in two books, *The Church and the Black Man* (1970) by John Howard Griffin and *The Black Photographers Annual* for 1976. He lived in St. Louis from 1984 to 1988 but recently moved back to his home state of Ohio. His current goal is to pursue color photography more strongly in the future.

Sherry Lubic (pp. 39, 111) specializes in nature, wildlife, and travel photography. Motivated by a deep concern for the environment, she uses her photography to show others the beauty of the natural world. Her work has appeared most recently in *Pacific Discovery, Midwest Motorist,* and wildlife calendars. Sherry and her writer-photographer husband recently formed Lubic & Lubic Photography, which she runs out of their home in rural Defiance, Missouri.

William K. Luebbert (pp. 14, 32) initially developed his photographic skills as a school photographer in the late 1940s. He uses Olympus SLR equipment exclusively in his award-winning photography. Ken, a member of the Photographic Society of America, is employed by McDonnell Douglas Corporation as a branch manager. He finds St. Louis to be a great photo subject with a superb blend of old and new architecture, ethnic variety, outstanding celebrations, and friendly, fun-loving, and caring people.

Mickey McGregor (p. 75) takes pictures as a hobby. She was born in the St. Louis area and has lived there almost all her life. She enjoys all outdoor photography and unposed children opportunities.

Joseph V. McKenna (p. 20) has enjoyed two careers—as engineering professor and as labor arbitrator. In recent years photography has been a major interest for him. His favorite subjects (flowers, landscapes, architecture, and people) have been provided by the city of St. Louis and travel here and abroad. His work has been published in *Photographer's Forum* magazine's *Best Photography Annual* (1984–1988).

Paul Marshall (pp. 70, 120) is a native St. Louisan and has been an amateur photographer for twenty years. Employed by McDonnell Douglas, he enjoys spending his spare moments creating images of the natural beauty of the St. Louis area. Color astrophotography and eagles wintering along the Mississippi are of particular interest to him.

Jon W. Marx (p. 104), a plant physiologist with Sigma Chemical Company, is a member of the St. Louis Camera Club. He became involved with photography in his teens when he participated in a Philmont Scout Ranch expedition in New Mexico. The trip also gave this Ohio native his first view of St. Louis. While anything interesting can be a subject for his camera, he specializes in nature, landscapes, and railroads. His work has appeared in model railroad magazines.

Stanley M. Miller (pp. 76–77) earned a Bachelor of Fine Arts degree from the University of Missouri–Columbia. He has worked as a photographer and graphic artist and is now employed at the UMC School of Journalism. His work has been exhibited and collected throughout Missouri.

Charles Morgan (p. 33) has been an active photographer for about eleven years, mainly in the fields of pictorial color and nature. His first love is nature photography and the study of nature. He has been an active member of the St. Louis Camera Club since 1982, and in 1988 he won the Nature Slide of the Year award in that club. He is presently a senior design technician at Campbell Design Group in St. Louis. His photographic work was recently represented in the book *Colorful Missouri.*

Leo H. Moult (pp. 4–5, 42) is pursuing a lifelong interest in photography more actively since retiring from McDonnell Douglas, where he was employed as a graphic artist. His photographs have appeared in several leading publications. He now owns and manages a studio, specializing in portrait and wedding photography.

Kathleen M. O'Donnell (pp. 71, 100–101) has pursued photography since her membership in the Dublin, Ireland, Camera Club in 1982. As a current member of the St. Louis Camera Club, she has found acceptance for her photography, particularly a photo sequence titled "What Kind of Child Are You?" Her ambition is to pursue professional editorial and commercial work.

Tom Patton (p. 40) is an associate professor of art at the University of Missouri–St. Louis. His photographs have been displayed in more than one hundred exhibitions throughout the United States, Europe, and Australia. Tom's works have been collected by many important museums, including the San Francisco Museum of Modern Art, St. Louis Art Museum, Art Museum at the University of New Mexico, and the Australia National Gallery. His photographs have appeared in many books and periodicals such as *Artweek, Afterimage,* and *The Photo Review.*

Kristen Peterson (p. 48) began her career fifteen years ago after graduating from Hamline University in St. Paul, Minnesota, with a double major in art and business. Based in St. Louis, Peterson specializes in editorial and industrial photography, and she has a strong interest in shooting people. Her work has been published in annual reports, brochures, local and national newspapers, and magazines including *Women's Wear Daily, W, Town and Country, Newsweek, U.S. News and World Report,* and *People.* She has won numerous awards from the National Federation of Press Women.

Robert Pettus (p. 71) received a B.S. in architecture from Washington University. He worked as an architect for Hellmuth, Obata & Kassabaum in St. Louis from 1963 until 1970; since then, he has directed his own architectural photography firm, serving national and international architectural firms and publishers, among other clients. His photographs have been featured in solo exhibitions recently at the Martin Schweig Gallery in St. Louis and at the School of Architecture at Kansas State University. They have also appeared in several books, including *Westmoreland and Portland Places* by Julius K. Hunter (University of Missouri Press, 1988).

Lewis Portnoy (pp. 12–13, 26, 30, 41, 64, 95, 108, 115, 121) is a photographer whose work from over two thousand assignments in sports journalism and location photography for advertising and industry has gained international respect. Since his beginning as photographer for the St. Louis Blues, Lewis has photographed nearly every major sporting event in North America. A St. Louis–based free-lance photographer, he has worked for the three television networks, major corporations, advertising agencies, and major publications and has conducted many photographic classes and workshops.

Robert J. Rohlfing (p. 22), a lifelong resident of St. Louis and a recently retired public utility employee, will soon be a ten-year member of the St. Louis Camera Club and the Photographic Society of America. He will continue a second career by pursuing his photography interests as a free-lance photographer and teaching photography to adult education students in the St. Charles School District.

Garry Rose (pp. 25, 114), a native of St. Louis County, is an optical engineer for McDonnell Douglas Corporation. He enjoys combining his hobbies of camping and backpacking with his love of nature photography. His work has won numerous awards around the St. Louis area and has been published in two books.

Michael Rudman (p. 13) has had photography as a hobby for most of his adult life, but he began pursuing it seriously when he joined the St. Louis Camera Club eleven years ago. He is also a member of the Photographic Society of America and has been successful in local and international competitions. He enjoys darkroom work, where he prints both color and black-and-white photographs. His subject matter is varied, including nature and travel, but his favorite form is photographing people in their natural environment.

Naomi Runtz (p. 27) has worked primarily in black-and-white photography for the past ten years, but she is currently exploring the creativity of the color process both through the camera and in the darkroom. She has shown in exhibits at the St. Louis Artists' Guild, St. Louis Women's Caucus for Art, and the St. Louis Artists' Coalition.

Linda Smith (p. 39) began amateur photography five years ago when she and her husband, Harlan, went to Kenya. The Smiths work as a team in all of their photographic pursuits, including membership in the Kansas City Color Slide Club, where both have received several contest prizes. They have also given joint travelogues. Wildlife photography is their main hobby, and they were able to pursue this interest in a recent trip to Zimbabwe. When not in Africa, they enjoy zoo photography.

Scott Smith (pp. 43, 46, 78) likes to take pictures—of everything. His interests and techniques are as varied as there are things to photograph. Assignments have taken this Brooks Institute graduate to every major city in the United States as well as to Japan and Hong Kong. Still, he insists he draws most of his inspiration from family photo albums.

Jim Sokolik (pp. 36, 38, 44, 50, 58, 63, 69, 81, 93) began his involvement with photography with a desire to document the life and culture of distant lands. Later, he became aware of the visual richness of St. Louis, his home town. He continues to explore the city and to photograph its people and architecture. Doing his own darkroom work has been an important and creative part of his photography. He is a professional photographer, and his work has been exhibited and published nationally.

Ernst Stadler (p. 43), a member of the St. Louis Camera Club, was born and grew up on the banks of the Danube in Bavaria. He combines his interest in photography and travel with a longtime fascination for American history, especially that of the American West. His translation of the 1844 travel diary of a German paleontologist was published by Southern Illinois University Press. He is also the author of articles and book reviews on early travelers and settlers, a past president of the St. Louis Westerners, and a former editor of *Westward* magazine.

Gary Tetley (pp. 29, 53, 60–61, 83, 98) is a native of St. Louis and an architect. He is dedicated to the preservation of the city's rich architectural heritage. He brings his own unique artistic abilities to the documentation of the significant buildings in the nineteenth-century commercial and industrial districts. His work has been exhibited in numerous galleries and is included in several corporate collections.

J. Michael Todd (p. 59), a student at the University of Missouri–St. Louis, has worked extensively on the gentrification of Soulard. His work includes the residents, buildings, and landmarks unique to that historical area. He has also photographed the St. Louis skyline from that South Side vantage point.

David Ulmer (p. 106) is a commercial photographer who lives in St. Louis County. His work has appeared in *Natural History, Sierra,* and *Missouri Conservationist,* as well as in the book *Colorful Missouri.*

Jonathon Westland, a high school senior, has been involved with photography for the past four years. He has worked mainly from his strong desire to create an acceptable portfolio. In order to support this preparation for a possible career in some area of photography, he has earned money by shooting various assignments, from biological coldrooms for medical testing to congressional parties to church interiors.

Bob Williams (pp. 66, 82), a graduate of Lincoln University in Jefferson City, changed careers to photography after learning photographic skills on his own. His photographs primarily appear in the African-American press in St. Louis. His portfolio includes work for the wire services and national publications like *USA Today.* Model composites, publicity, products, and color round out his interests. He is a member of the Independent Photographer's Association.

Gregory Wolff (p. 117) is an art student specializing in graphic design. His love for photography has inspired him to study it as both a fine and a graphic art. Like drawing, he sees photography as one of many tools artists use to interact with their visual environment. He plans a career that combines photography with the graphic arts.

Cindy Wrobel (pp. 37, 54–55) works as a graphic designer and illustrator. She also continues a lifelong development of her personal art, drawing and photography. A native of Michigan, Cindy has lived in St. Louis nine years. Through her unending exploration of the city with her husband, she has discovered many of the unique places and qualities that make St. Louis special.

Thomas Zant (p. 21), professor of political science at St. Louis Community College at Forest Park, has had a lifelong interest in photography. He has been able to pursue this more actively for the last five years, concentrating on travel, wildlife, and landscapes. He works exclusively in 35mm, and although he prefers color, he has recently been experimenting with black and white.

Library of Congress Cataloging-in-Publication Data

Scott, Quinta, 1941–
 Images of St. Louis / contemporary photographs selected by Quinta Scott ; introduction by Elaine Viets.
 p. cm.
 ISBN 0-8262-0697-2 (alk. paper)
 1. Saint Louis (Mo.)—Description—Views.
2. Saint Louis Region (Mo.)—Description and travel—Views. 3. Saint Louis (Mo.)—Social life and customs—Pictorial works. 4. Saint Louis Region (Mo.)—Social life and customs—Pictorial works.
I. Viets, Elaine, 1950– . II. Title.
F474.S243S36 1989
977.8′66—dc20 89–4836
 CIP